artful jesters

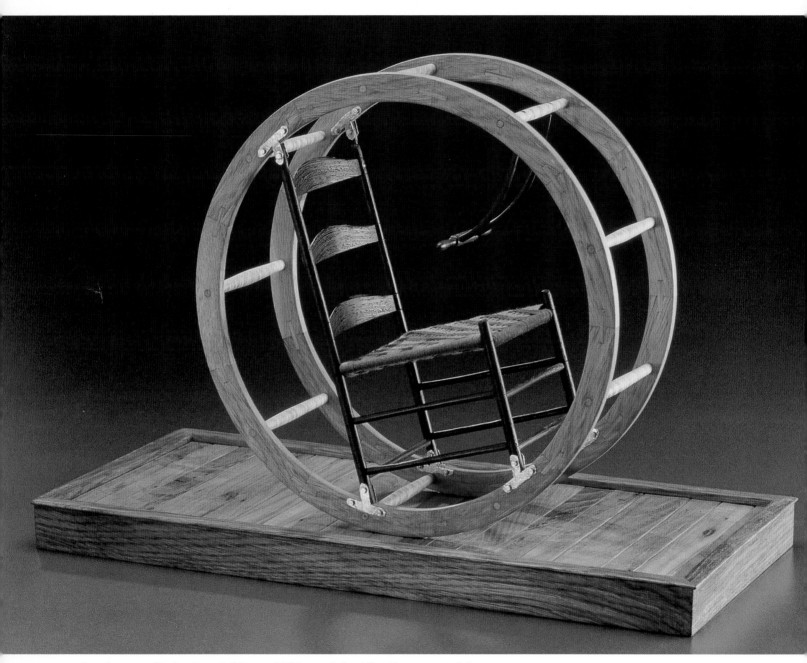

Roy Superior. *Shaker Downhill Racer*, 1984, wood, 9 x 12 x 6", courtesy of the artist.

INNOVATORS
OF VISUAL WIT
AND HUMOR

artful jesters

Nicholas Roukes

TEN SPEED PRESS
Berkeley / Toronto

Ten Speed Press
P.O. Box 7123
Berkeley, California 94707
www.tenspeed.com

Distributed in Australia by Simon & Schuster Australia, in Canada by Ten Speed Press Canada, in New Zealand by Southern Publishers Group, in South Africa by Real Books, and in the United Kingdom and Europe by Airlift Book Company.

Cover design by Betsy Stromberg

Text design by Betsy Stromberg based on an original design by Toni Tajima

Front cover illustration by Willie Cole, *Burning Hot I*, 1999, Sunbeam iron with yellow and red feathers, 10 x 7 x 12^1/$_2$″, Alexander and Bonin Gallery, New York.

Back cover illustration by Gerald Purdy, *Changing Scene*, 1999, oil on canvas, 30 x 40″, courtesy of the artist.

Spine illustration from *Windsong*, by Gerald Purdy, 2000, oil on panel, 15 x 20″, courtesy of the artist.

Library of Congress Cataloging-in-Publication Data
Roukes, Nicholas
 Artful jesters : innovators of visual wit and humor / Nicholas Roukes.
 p. cm.
 Includes bibliographical references.
 ISBN 1-58008-266-1 (pbk.)
 1. Wit and humor in art—Catalogs. 2. Fantasy in art—Catalogs. 3. Art, American—20th century—Catalogs. I. Title.

N8212.R67 2003
709'73—dc22 2003017333

First printing, 2003
Printed in Hong Kong

1 2 3 4 5 6 7 8 9 10 — 07 06 05 04 03

dedication
FOR JULIE AND THE HUMOR MUSE

Peter Coes. *She Ran to the Edge of the Island and Waved until He Was Out of Sight,* 1996, acrylic on panel, 32 x 40", courtesy of the artist.

Beyond common sense lies
a universe of utter chaos,
unrelieved nonsense and
riotous freedoms of expres-
sion. Under their influence,
our universe is refreshed,
and we begin to reinvent
our relations to the world.

—Mission statement,
Museum of Laughter,
Montreal, Quebec

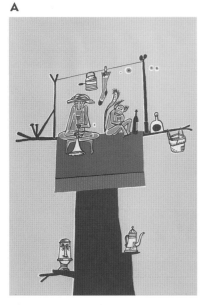

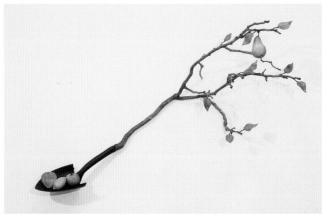

A Walter Askin. *Sampath,*
2001, lithograph,
16 x 22", courtesy of
the artist.

B Victor Cicansky. *Garden
Spade,* 1997, wood, acrylic,
and paint, 99 x 63 x 24",
courtesy of the artist.

contents

C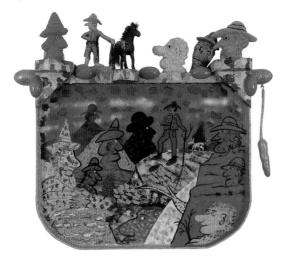

D

C Roy De Forest. *Return to St. Helena,* 1997, acrylic and mixed media on masonite, 45 x 50 x 9", George Adams Gallery, New York.

D Guy Johnson. *Self-Portrait,* 1983, oil on paper on aluminum, 20 x 27$^{1}/2$", Louis Meisel Gallery, New York.

A Craig Nutt. *Tactical Tuber,* 1989, oil on carved wood, 22 x 15 x 21", courtesy of the artist.

B Jim Picco. *Knock-Kneed Chauffeur,* 1997, crayon on paper, 38 x 50", courtesy of the artist.

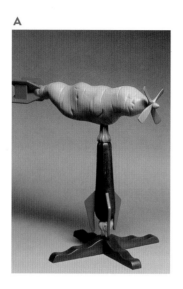

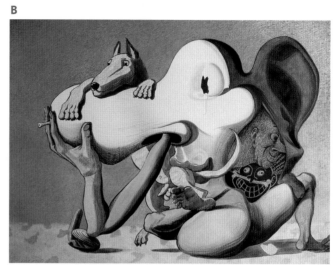

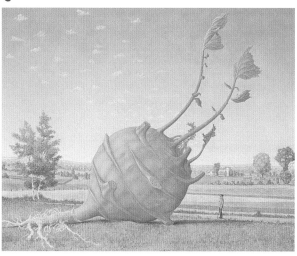

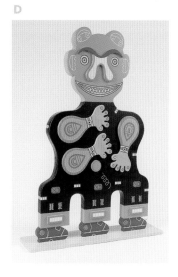

C John Wilde. *View Near Stebbinsville Road with a Giant Kohlrabi,* 1983, oil on panel, 10 x 12", Schmidt-Bingham Gallery, New York.

D Karl Wirsum. *Mr. Answer Pants,* 1991, acrylic on wood, $49^{1}/_{2}$ x 36 x 9", Jean Albano Gallery, Chicago.

acknowledgments

I am grateful to the artists who have contributed much of the material included in *Artful Jesters*, and extend to them my heartfelt thanks and best wishes for their continuing success. I am also thankful to the agents, gallery directors, and institutions who have helped to transform *Artful Jesters* from an ephemeral idea into a tangible reality. Special acknowledgments to the following: George Adams Gallery, New York; Jean Albano Gallery, Chicago; Albright-Knox Gallery, Buffalo, New York; Alexander and Bonin Gallery, New York; Art Resource, New York; Eva S. Belavsky; John Berggruen Gallery, San Francisco; Galerie Isy Brachot, Brussels; Rena Bransten Gallery, San Francisco; Braunstein-Quay Gallery, San Francisco; The British Museum, London, England; Patrick Cudahy; David Findlay Jr. Inc., New York; Fredericks Freiser Gallery, New York; Glenbow Museum, Calgary; Walter Gruen; Wanda Hansen; Nancy Margolis; Susan Landauer; Bill Maynes Gallery, New York; Louis K. Meisel Gallery, New York; Metro Pictures Gallery, New York; Musée National du Louvre, Paris; The Museum of Modern Art, New York; John Natsoulas Gallery, Davis, California; Nelson-Atkins Museum, Kansas City, Missouri; Lewis Newman; Newspaper Enterprise Association; Frank Paluch, Perimeter Gallery, Chicago; Maya Polsky Gallery, Chicago; SCALA, New York; Schmidt-Bingham Gallery, New York; School of the Art Institute of Chicago; The

Smithsonian Institution; Solomon-Dubnick Gallery, Sacramento, California; Tibor de Nagy Gallery, New York; VAGA, New York; Shannon Trimble; United Media, New York; Susan Whitney Gallery, Regina, Saskatchewan; Whitney Museum of American Art, New York.

I am thankful for the procreative iconoclasm of Robert Arneson (1930–92) whose work ethos inspired many of the artists in this book. His legacy continues to shine.

Finally, *Artful Jesters* would not have been possible without the vision and support of Phil Wood; the editorial and production staff of Ten Speed Press; my editor, Meghan Keeffe; and book designers Betsy Stromberg and Toni Tajima.

A special thank-you to Richard Waller, director of the Marsh Art Gallery, University of Richmond, Virginia, for reading the manuscript and providing constructive comments.

As always, my gratitude to Julie, for her faith, support, and editorial assistance.

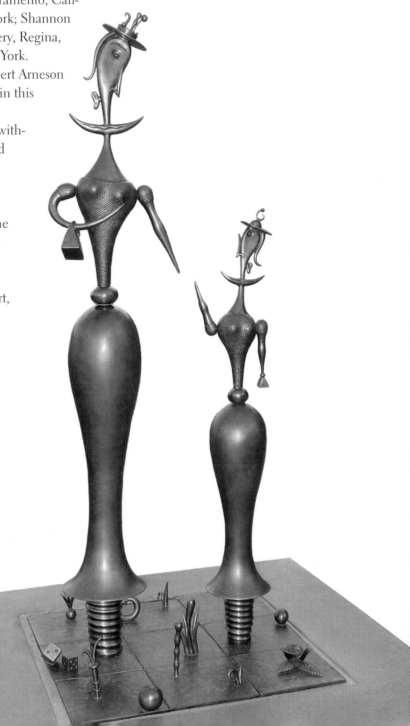

Tom Rippon. *Proper Shoppers*, 2002, bronze, 80 x 48 x 48", courtesy of the city of Missoula, Montana.

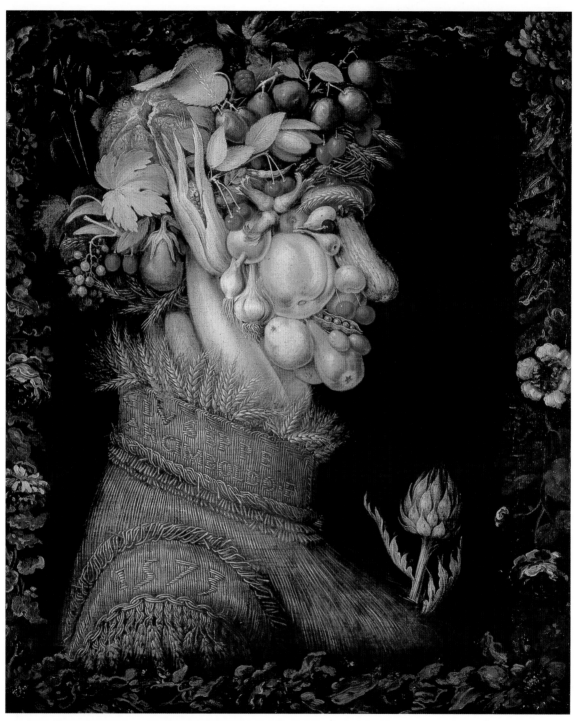

Giuseppe Arcimboldo. *Summer,* 1573, oil on canvas, 30 x 25", Musée National du Louvre, Paris, photo courtesy of Reunion de Musées Nationaux.

introduction: entreating the mirthful muse

Artful jesters are artists who see and interpret the world from a different slant, a view that is typically ironic, witty, often contentious, yet always innovative and provocative. Guided by Thalia, the benevolent muse of humor, they dish out colorful, wide-ranging expressions that extend from benign whimsy through lighthearted parody and mordant satire to inspired visual nonsense.

This introduction describes the track record, events, and personalities of visual humor from the historical perspective and also provides information about the spirit and mechanisms that tend to kindle humor and laughter. It is meant to serve as an orientation to visual humor, not as a thorough review.

Following this are profiles of fifty contemporary artful jesters, a virtual exhibition of visual humor by artists who imbue their expressions with various genres and blends of playful wit and ingenuity. Some, like David Gilhooly, William T. Wiley, Roy De Forest, Peter VandenBerge, Gladys Nilsson, Jim Nutt, and John Wilde, are veteran players in the field of visual humor. Joining them are many artists of commensurate talent, some of whom are emerging newcomers to the field. Although *Artful Jesters* features fifty artists, it could easily have included a hundred more. Only the publication limitations precluded incorporating additional work.

Hilaritas sapientiae et bonae vitae proles. (Mirthfulness is the offspring of wisdom and good living.)

—ANON

1

The First Artful Jesters

From the time of ancient Sumeria to the present day, the world has been enhanced by the existence of maverick artists who have sought to amuse, provoke, and enlighten viewers with exhibitions of visual wit. Among such artists are Hieronymous Bosch (1450–1516), an artist from the mid-fifteenth century who painted grotesqueries of hybridized creatures and demons and nightmarish scenes of hell, followed by Pieter Bruegel (1525–69), the great Netherlandish painter and graphic artist who produced satiric drawings to expose the weaknesses and follies of his sixteenth-century culture.

Later, with the loosening of classic ideals during the Renaissance, and with a shift to fantasy, exaggeration, and novelty by sixteenth-century Italian Mannerists, came the idiosyncratic portraiture of Giuseppe Arcimboldo. Arcimboldo (1537–93), a Milanese artist, scientist, and engineer, worked in both traditional and grotesque styles, but he drew attention for his bizarre portraits that were comprised of clever arrangements of fruits, vegetables, and miscellaneous objects. Although he failed to be appreciated by his contemporaries, who felt that he mocked their reverence for the human face as the mirror of the soul, he was acclaimed as a progenitor of surrealism four hundred years after his death.

Other early exponents of visual humor include Annibale Carracci (1560–1609), a member of a sixteenth-century Italian family of painters who created comic portraits they called *caricaturas* (given to mean "loaded" portraits), which were created in the spirit of whimsy rather than for social or political criticism.

Jacques Callot (1592–1635), a mid-seventeenth-century French engraver, worked in Italy and became one of the chief exponents of a fashionable grotesquerie that centered on presentations of comic fanfares of dwarfs, vagabonds, and street people. British caricaturists William Hogarth, James Gillray, and Thomas Rowlandson, among other contemporaries, satirized the social and political eccentricities and follies of the eighteenth-century English. Honoré Daumier (1810–79), a mid-nineteenth-century French painter and caricaturist, skewered corrupt French politicians. The Belgian artist James Ensor (1860–1949), whose images centered on grotesque figuration and macabre scenarios and processions with morbidly humorous overtones, was another forerunner of surrealism.

The Irony of Humor and Art History

Although it is generally acknowledged that a sense of humor is one of mankind's most valuable attributes, writers of art history books have not been entirely clear on the concept, and, for the most part, have ignored the existence of visual humor. Ironically, it was not until the early part of the twentieth century that humor eventually got a foot inside the door of mainstream art.

Why this anomaly? One reason is that the classic notion of comedy, which began with Aristotle, considers the function of comedy to be a corrective—a means of directing laughter at folly and vice so wrongdoers will mend their errant ways. Therefore, from the Aristotelian point of view, comedy was perceived as an aid for the preservation of morality. The serious tone of medieval ecclesiastical and feudal culture attached a stigma to hearty laughter. Boisterous jocularity was viewed as a character flaw, and as an act of obnoxious behavior by ill-mannered fools. The clergy preached the evils of humor and proclaimed it to be "the work of the devil," a sign of blasphemy and the repudiation of civil and spiritual obedience.

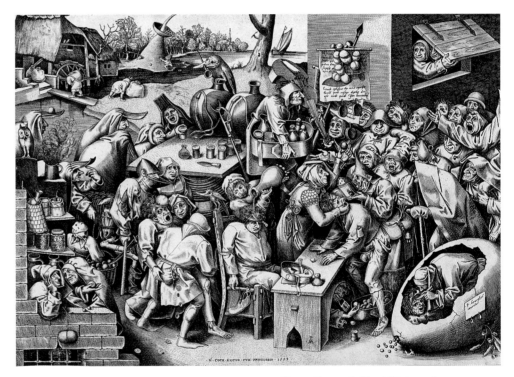

Pieter Bruegel. *The Witches of Maleghem,* 1559, engraving, 12³/₄ x 18", The British Museum, London.

The same blinkered, sixteenth-century mentality that held humor and foolishness as an aberrant condition also believed that in less serious cases it could be cured by surgery. In the *Witches of Maleghem* (1559), Pieter Bruegel depicts a doleful scene where the citizens of Maleghem (Fool Town) are shown in clamorous disorder. Sorcerers (scalpel-wielding primitive physicians) are portrayed curing

foolishness by surgically extracting egglike stones of folly from the heads of the afflicted, a procedure followed by a cranial purgative to remove remaining traces of the disease. In the right corner of Bruegel's composition is a huge egg (presumably the operating room) in which a patient sits appearing blissfully happy to be rid of his affliction. Foolishness, in the form of tiny orbs, is seen discharging from his head.

Arising concurrently with the restraints imposed by medieval ecclesiastic authoritarianism, a wave of revolt from the populace brought about an acquiescence by the church, which provided for limited revelry. In *Rabelais and His World*, Mikhail Bakhtin writes that the Middle Ages have been badly misrepresented by writers of history. He claims that these historians neglected to explore the celebratory nature of the people's laughter, and the manifestations of folk humor in such events as carnival and other church-sanctioned festivals.[1]

In today's enlightened age, things are different. Humor and laughter, and the appetite for comic fantasy, say our psychologists, are not only wholesome and hygienic, but of crucial importance for the revitalization, transformation, and celebration of life.

When Norman Cousins investigated humor in the 1970s, he found conclusive proof that laughter stimulates the release of endorphins in the body. Cousins concluded that people feel better when they laugh because endorphins diminish physical and emotional pain.[2]

Artists of humor, therefore, are triply blessed, benefiting from the joys of laughter, the satisfaction of aesthetic creativity, and the curative properties of good medicine.

The Metaphysics of Mirth

What's so funny (and ironic) about humor is that its catalyzing agents—incongruity, ambiguity, inconsistency, irony, mystery, and contradiction—which are considered problematic by serious-minded folk, are fervently adopted as working tools by humorists. Rather than dismissing elements of anomaly as chaos producing, they are, instead, embraced as procreative springboards for artful expression.

Humorologists say all jokes, whether verbal, literary, or visual, pivot on the interplay between familiarity and surprise. A joke isn't a joke if the audience doesn't get it; that is, if it doesn't have a frame of reference with which to make an analogy that would prompt the aha insight. (In this usage, "frame of reference" refers to each person's storehouse of information that is churned up during attempts to

solve puzzlements, and "surprise" refers to the twist or witwork that the artist applies that transforms something familiar into something absurd—and potentially funny.) The artful jester knows that the act of creating humor is much like making an omelet: you can't make an omelet without cracking eggs, and you can't make a joke without cracking frames—the eggs of expectation.

Although the terms "wit" and "humor" are often used interchangeably, there is a significant difference between them. Whereas humor is entertaining, wit makes you think and look at things in a different way. Quintilian, the first-century Roman orator, described wit as a product of conscious mental agility partaking of a certain tincture of learning, charm, saltiness or sharpness, and polish and elegance. Sigmund Freud, in *Wit and Its Relation to the Unconscious* (1905), said wit is made, but humor is found. Freud astutely noted that a common technique of wit-work is "representation through the opposite," and that wit permits expression of feelings and ideas that would otherwise remain repressed.

Why Do We Laugh?

Regardless of the remarkable achievements in science and medicine, the essence of laughter still remains a mystery. Comedian Steve Allen accurately stated that analyzing humor is like trying to grab a bar of soap in the tub. When you think you've got it, you don't.

Conditions and timing are important factors for humor to flourish. Furthermore, each person's frame of reference, cultural background, age, education, and psychological disposition also contribute to the schooling of one's HQ (humor quotient), the comic sensibility that discerns what's funny or what isn't.

Traditional doctrine classifies humor into three main groups: incongruity theory, superiority theory, and relief theory.[3] Incongruity theory is based on surprise and contradiction. We laugh at the way things are as compared to the way they ought to be. Jokes, therefore, are exploded expectation systems. Humorists use surprise, irony, reversal, exaggeration, ambiguity, transposition, contradiction, hybridization, distortion, metamorphosis, fragmentation, and superimposition, among other mechanisms, to kick-start creativity and to elevate undeveloped incongruity into polished structures of hilarity.

Superiority theory holds that laughter is prompted by feelings of condescension. It capitalizes on the misfortune of others, and it is probably the oldest model of humor, dating back to the ancient Greek civilization of Aristotle and Plato. By

focusing on the incompetence, stupidity, handicaps, mistakes, or foolish behavior of others, this aggressive form of humor draws laughter at someone else's expense. The court jester and the satirist, throughout time, have used disparaging and self-deprecating humor to entertain as well as to goad skeptics and oblivious folks toward new insights.

Relief theory pivots on Sigmund Freud's notion that jokes are ways of gratifying taboo wishes, which in turn can serve as a cathartic mechanism to help release tensions and pent-up emotions. The interplay of laughter and release is basic to the success of parody, satire, and dark humor, particularly when enlightenment is gained through an objective detachment furnished by comic ploy. The Greek word *catharsis* denotes clarification, and from one perspective it can be further interpreted as intellectual illumination.

Jim Nutt. *An Imperative,* 1983, colored pencil on kraft paper, 12$^1/8$ x 14$^1/8$", courtesy of the artist.

Obviously, all humor depends on incongruity theory as a creative tool, as illustrated in the ensuing work by the artful jesters. Many of their works, in varying degrees, blend in superiority and relief theory as well.

The cartoonlike figures by Tom Rippon and Peter VandenBerge, for example, resonate with whimsical incongruity. The loony generals and warlords by Mark Bryan, the assembly-line robots by Warrington Colescott, and the demonic brutes in Carrol Dunham's pictorials fit the superiority genus. The comic sanctimony of Mick Sheldon, the gender-oriented mythology of Gladys Nilsson and Patti Warashina, the artful toys by C. W. Hurni and Gina Kamentsky, and the whimsical compositions of Jim Nutt correspond to the relief hypothesis.

It should be noted, however, that the study of humor is far too complex to be explained by single-factor theories, and that the three stimulus theories should provide only a starting point for those bent on further research.

Great art is always multilayered and elusive, defying categorization or tight-fitting labels. Theories should be taken with a grain of salt. Ultimately, it's up to the individual viewer to discern the psychological and metaphoric dimensions of a work of art. The fact that most artists seem uninterested in theoretical approaches and create art largely by intuitive means suggests that intuition is probably the best way for the viewer to respond to it as well.

Humor: Creativity in Action

For the visual humorist, humor and creativity are synonymous in that both issue from a fired-up imagination that employs four key functions: (1) *synthesis*, the mind's ability to form unified patterns out of chaotic input and multiplicity of stimuli; (2) *simplification*, the mind's ability to reduce complexities to essences and basic elements; (3) *detachment*, the disassociation of logical (left brain) thinking, which in turn allows insights to occur from intuitive (right brain) thinking; and (4) *energizing*, activating the mind (both irrational and rational modes) to make new connections, associations, and modifications. The coordinated mental activity that energizes both modes of thinking therefore acts as a distinct tool for problem solving and creative expression.

Although incongruity is clearly an important stimulus for creativity, by itself it is not constructive. Only when it is mobilized by the intuitively oriented right brain and linked to conscious deliberation by the rational left lobe do imaginative thinking and the aha response begin to emerge.

FRANK AND ERNEST

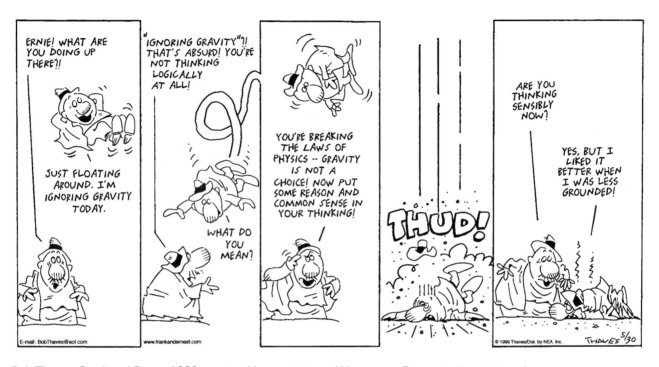

Bob Thaves. *Frank and Ernest,* 1999, reprinted by permission of Newspaper Enterprise Association, Inc.

Comparing Verbal and Visual Humor

Although verbal and visual humor share certain similarities, both being based on irony and witwork, they differ in two respects. First, visual humor is different because it is obviously a sight-based experience. Second, unlike literary or verbal humor, where information is presented in a bit-by-bit, forward-moving sequence, with the punch line coming at the end, visual humor (as in a painting, sculpture, or mixed-media work, but excluding comic strip art) presents everything—the narrative and the "punch line"—simultaneously. It's as if to say, "Here's the answer, what's the question?"

Visual Humor Steps into the Twentieth Century

During the great fervor of artistic innovation in the early 1900s, humor made a quantum leap into the vanguard of high art, due mainly to the efforts of Pablo Picasso and his contemporaries, Joan Miró, Marc Chagall, Paul Klee, Marcel Duchamp, Max Ernst, Alexander Calder, Jean Dubuffet, and René Magritte. It was Picasso, in the early 1900s, who startled the art world by using the vernacular of caricature in making a series of funny faces and figures, a style he continued to employ throughout his career.

In 1913, the puckish Marcel Duchamp (1887–1968) pushed art to the edge when he mounted a bicycle wheel on a wooden bar stool and called it art. In 1917 he again caused an uproar by exhibiting a urinal that he had signed with his alias, R. Mutt. He caused even further controversy two years later when he "revised" da Vinci's Mona Lisa by painting a mustache and goatee on a reproduction of the famous image. Marcel Duchamp, ever the irrepressible provocateur, was a principal player in American dadaism, which put forth the precept of ready-made art: the notion that any found object (a bottle rack, bicycle wheel, or urinal) can be exhibited as fine art. Thanks to Duchamp's shenanigans, the art world would never be the same.

During the mid-1920s, Joan Miró produced some surreal compositions that were in part inspired by the comics. George Grosz's trenchant wit is revealed in his biting social and political satire of the 1920s. Paul Klee painted his whimsical *Twittering Machine* in 1922, and René Magritte painted *The Treachery of Images* (This Is Not a Pipe) in 1928. Meret Oppenheim's *Object* caused a mild sensation when it appeared in 1936, as did Jean Dubuffet's primitive style that he labeled "art brut," which was introduced in the 1940s. Picasso's mischievous wit and penchant for making visual puns blossomed with the creation of *Bull's Head* (1943), a sculpture of a fanciful horned beast made by cleverly recombining the handlebars and seat of a bicycle. Maurits Escher (1898–1972) was a master of visual illusion, and he created entertaining compositions of tightly interwoven shapes where foreground and background figures of animals, birds, and fish are made ambiguous and virtually flip-flop upon contemplation by the viewer.

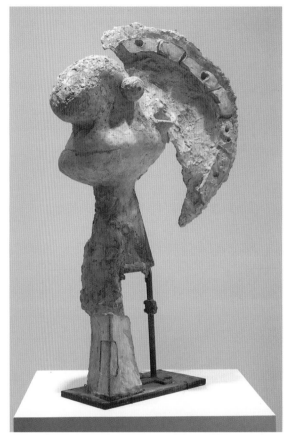

Pablo Picasso. *Head of a Warrior,* 1933, plaster, wood, and metal, 47^1/$_2$ x 9^3/$_4$ x 27", The Museum of Modern Art, New York, licensed by SCALA.

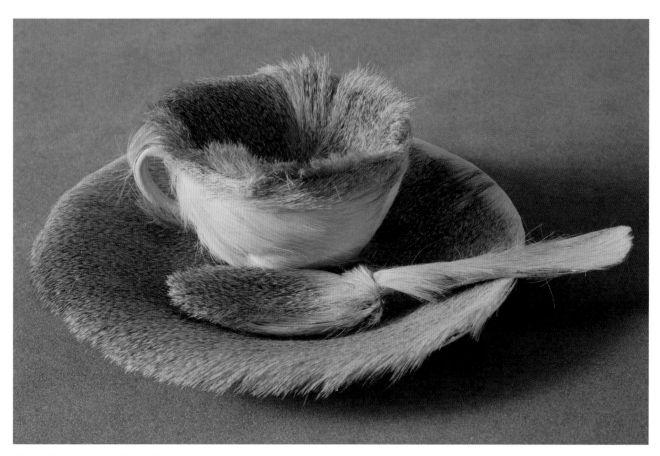

Meret Oppenheim. *Object* (Le Déjeuner en Fourrure), 1936, fur-covered cup, saucer, and spoon, 9³/8 x 2 ⁷/8", © The Museum of Modern Art, licensed by SCALA, Art Resource, New York.

Alexander Calder, with great wit and humor and a joy for experimentation with toy design, created an elaborate, miniature circus between 1926 and 1930. The "tiniest show on earth," as it was called, is an intricate assembly of lilliputian jugglers, sword swallowers, clowns, and animals crafted from materials such as cork, wire, wood, yarn, paper, string, and cloth. Calder manipulated the movements of each character in performances held at various locations in Paris and New York through the mid-1930s. Calder's circus, now in the Whitney Museum of American Art, as well as his humorous caricatures made of wire, helped to establish humor in mainstream art.

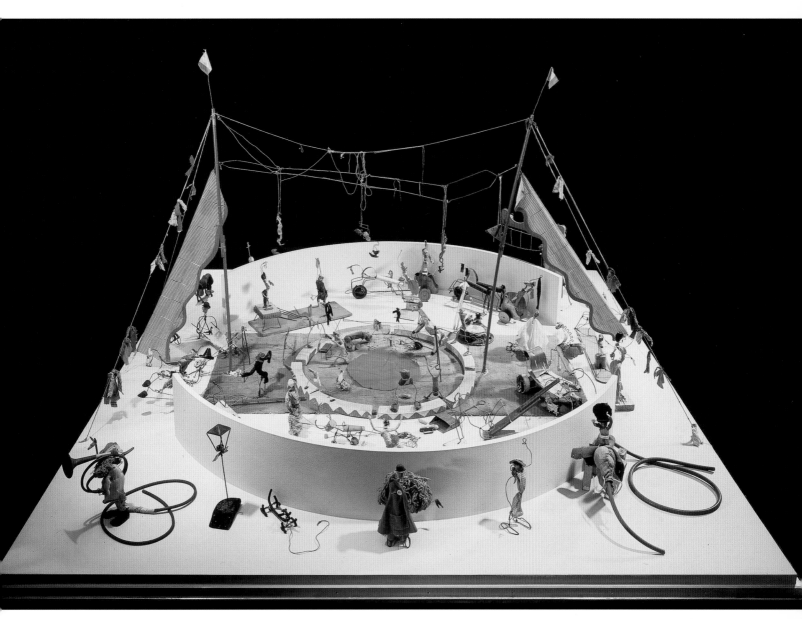

Alexander Calder. *Seals from Calder's Circus,* 1926–30, painted wood, metal, wire, cork, and plastic ball, 8 x 19⅝ x 5", photo © 1996 Whitney Museum of American Art, New York.

Dada: Off the Easel and Over the Edge

Dadaism (circa 1915–22) was not so much an art movement but, as Tristan Tzara put it, "a state of mind." It was a short-lived antisocial manifestation by young poets, artists, writers, and musicians in Zurich, Berlin, and New York who were utterly disgusted by the immorality of society and the barbarities of the Great War. Their nihilistic stance prompted notoriously flippant and absurd exhibitions and performances that included chance (for example, dropping or throwing paint from a brush), accident (uncontrolled or random procedure), decalcomania (squeezing blobs of paint between two surfaces, which are then separated while still wet), and other unconventional methods as various means of production. Jean Arp, Tristan Tzara, and Hugo Ball were the founders of dada. Key players included Francis Picabia, Man Ray, Kurt Schwitters, Max Ernst, George Grosz, Hannah Hock, Raoul Hausmann, and Marcel Duchamp.

Despite the movement's brevity, dada had a certain positive impact on subsequent twentieth-century art. Many of the playful and extemporaneous methods the dadaists employed were translated into standard studio practice by artists working in collage, assemblage, happenings, installation and performance art, mixed-media art, and action painting, and by poets writing stream of consciousness verse. Author George D. Culler notes that from the dada adventure emerged one of the most significant insights of the age: that through juxtaposition incongruous elements can become a *new* entity, not merely the sum of its parts.[4]

Comic Surrealism

Can dreams be funny? Of course. Whenever fantasy collides with reality as we know it, there is an inherent probability that laughable situations will arise. Like dreamwork, surreal art pivots on the undirected play of thought and the venting of the subconscious, and therefore has the potential to precipitate images and emotions that can vary from the comically absurd to the terrifying. In the *Surrealist Manifesto* (1924), André Breton—the founder and chief theorist of surrealism— described surrealism as associating conscious and unconscious experience in a way that unites dream and fantasy with the cogent workaday world, a method that evokes an *absolute* reality—a surreality. The art of Paul Klee (1879–1940) possesses a gentle humor, with allusions to dreams, music, and poetry. Albeit surreal,

it is also colorful, witty, and full of fun. *Genii* (Figures from a Ballet), is a light-hearted work inspired by subconscious impulse and the spirit of children's art.

Comic surrealism is characteristically seen in the work of Joan Miró (1893–1983), an artist who loved to paraphrase comic strip art, particularly the wacky and lovable *Krazy Kat* by George Herriman. Miró was purportedly lauded by Breton as an artist who had gained mastery over the uncontrollable, and worked in harmony with the unpredictable.

A

B

A Joan Miró. *Dutch Interior 1,* 1928, oil on canvas, 36^1/$_8$ x 28^3/$_4$", Museum of Modern Art, New York, Mrs. Simon Guggenheim Fund, licensed by SCALA.

B Paul Klee. *Genii* (Figures from a Ballet), 1922, watercolor on Ingres paper glued on cardboard, 10 x 7", Paul Klee Foundation, Kunstmuseum, Bern.

Spanish-born painter Remedios Varo (1908–63), while exiled in Mexico, produced a remarkable series of surreal works between 1949 and the early 1960s. Her amusing compositions, inspired in part by her interest in science and scientific inventions, pictured bizarre mechanical devices, eccentric vehicles, strange scientific apparatuses, and solar system models in odd combinations and hybrid forms. Her meticulously rendered paintings are reminiscent of a lighthearted Hieronymus Bosch, and they are amusing portrayals of sorcery and physics, with logic lying somewhere between the twilight zone of fiction and funky realism. Like dreams, Varo's surreal art sequesters unconscious emotions, and it is at once comical and disquieting.

Remedios Varo.
Creacion de los Aves
(Creation of the Birds),
1959, oil on masonite,
20^5/$_8$ x 24^5/$_8$", courtesy
of Walter Gruen.

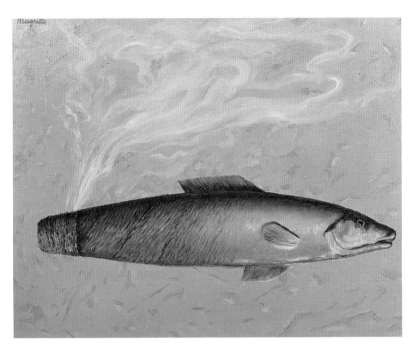

René Magritte. *L'Exception,* 1963, oil on canvas, 13 x 16", Galerie Isy Brachot, Brussels.

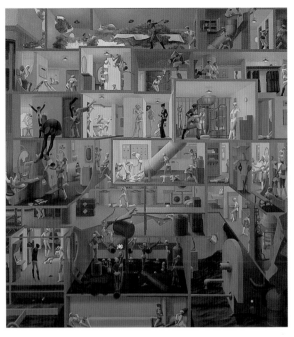

Hilary Harkness. *Sinking the Bismarck,* 2002, oil on linen, 40 x 36", Bill Maynes Gallery, New York, and Daniel Weinberg Gallery, Los Angeles.

The surreal art of Belgian-born René Magritte (1898–1967), painter, sculptor, and master of visual contradiction, inspires many contemporary artists. Magritte's dreamlike images are often comically surreal, and they evolve from the exploitation of ambiguity, absurd transposition, reversal, hybridization, metamorphosis, and unexpected encounter.

The surreal imagery of New York artist Hilary Harkness presents cross-sectional views of battleships and submarines in which the crews consist entirely of women. Using a compositional format that breaks the pictorial space into comic strip–like frames and a style of simplified magic realism, *Sinking the Bismarck* presents amusing bits of eroticism and surreality and hints at nascent global changes of gender roles and relations.

Art Brut

To the question, Should art be prudent? Jean Dubuffet once replied, "A prudent art: What a stupid idea! Art is a compound of intoxication and madness!"[5] Dubuffet coined the term "art brut" to describe artistic expression by people not academically trained or culturally indoctrinated. In 1945, he began a systematic collection of artwork and graffiti by psychotics, prisoners, mediums, clairvoyants, and other untrained artists, now housed at the Chateau de Beaulieu in Lausanne, Switzerland. Curator Michel Thevoz describes the collection as art by people who have produced expressions from the depths of their own personalities, and for themselves only. The works exhibit outstanding originality but owe nothing to tradition or fashion.

Inspired by these refreshing contributions, Dubuffet became an avid crusader for the study of outsider art—visual expressions by self-taught artists: the naive, the visionary, the intuitive, the eccentric, and the psychologically and developmentally disabled. In December 1951 he presented a lecture in Chicago titled "Anti-Cultural Positions," which had an enormous impact on some of the unfledged Chicago artists in search of an identity outside the precepts of New York's abstract expressionism.

"I aim at an art that is directly plugged in to our current life, that emanates from our real life and our real moods," preached Dubuffet.[6] Many of Dubuffet's own faux-naïf, mixed-media paintings (marked by the pretense of simplicity and innocence) comprise a medley of caricature and improvisation and an assembly of unorthodox materials such as shells, stones, butterfly wings, and macadam. His spirit resonates in Chicago imagism and California funk art of the 1960s, and it continues to influence many contemporary artists. As critic Harold Rosenberg once put it, "When one has looked at Dubuffet's paintings one looks at everything around one with a new, refreshed eye, and one learns to see the unaccustomed and amusing side of things."[7]

Jean Dubuffet. *Hunt for the Two-Horned Creature,* 1963, oil on linen, 59^{1}/$_{2}$ x 76^{7}/$_{8}$", Hirshhorn Museum and Sculpture Garden, Smithsonian Institution, Joseph P. Hirshhorn Purchase Fund, 1985.

Manifestations in the Sixties

The 1960s was a frenetic period in American art and culture, a time of social unrest and radical change: the Civil Rights movement, race riots, the Vietnam war, the Beatles, Motown, Marshall McLuhan, the free speech movement, psychedelic art, Haight Ashbury, LSD, love-ins, hippie culture, underground comics, and rock concerts. It heralded Betty Friedan's *The Feminine Mystique* and the gathering forces of the feminist movement, Martin Luther King Jr.'s "I Have a Dream" speech, and Malcom X's Organization of Afro-American Unity. It was the decade marked by the assassination of President Kennedy and the famous moon walk by Neil Armstrong and Buzz Aldrin.

Pop Art

In the art world, the 1960s was the era of pop art: Andy Warhol's Campbell's soup cans, Brillo boxes, and glorified images of Hollywood celebrities being notable examples. When pop art emerged in the United States and England, it triggered responses ranging from admiration to outright hostility. Critics predicted its early demise, but they were surprised to discover that pop became the dominant art movement of the 1960s, and Andy Warhol, Robert Rauschenberg, Jasper Johns, Roy Lichtenstein, Jim Dine, Tom Wesselmann, Claes Oldenburg, and James Rosenquist were key players. In England there was the pop coterie of critics Lawrence Alloway, Reyner Banham, and artists Richard Hamilton, Eduardo Paolozzi, William Turnbull, and Peter Blake, among others.

Interestingly, there was no official manifesto of pop. Instead, there was a contingent of like-minded artists who worked independently and with no agenda other than to promote the adaptation of images from consumer culture to fine art. Billboards, magazine advertisements, mass-produced consumer products, TV, movies, Hollywood celebrities, comic strips, technology, and science fiction were among the sources that provided imagery for these artists. As Claes Oldenburg, prominent among American pop artists, put it, "it was about making impersonality a style."[8]

Although pop art was derided by critics who declared it banal and empty of content, it received unlikely support from theoretician Roland Barthes, who agreed that pop art depersonalizes its subject, yet at the same time *retains* a subject. "What subject?—The one who looks," Barthes explained.[9]

Oyvind Fahlstrom. *Performing K. K. III,* 1965, oil and collage on canvas with four movable magnetized parts, 54^1/$_2$ x 36^1/$_2$ x 2", Robert Rauschenberg Foundation Collection.

Indeed. The question of whether an art image is boring or exciting clearly depends on the complicity of the viewer, the one who looks at it, for it is ultimately the viewer who completes the picture and determines its significance, funniness, or lack thereof. Perhaps pop art's redemption is in being a fly in the ointment of dogma, and for setting the stage for new movements to emerge. Critic John Canaday noted that the appearance of pop art was equivalent to the discovery of a critical Klondike, where new claims could be staked and new areas mined for interpretation.[10]

Artists who have used the vernacular of popular culture, but who have transfigured it by producing mythic images from those they have appropriated, are recognized, and rightly so, for having raised the standards of pop art. George Segal, Marisol, Eduardo Paolozzi, Allen Jones, Edward Kienholz, Philip Guston, Edward Ruscha, Clive Barker, Elizabeth Murray, Phillip Hefferton, and Oyvind Fahlstrom are noteworthy examples.

While pop art predominated in the 1960s, two secondary movements were brewing: Chicago imagism, spurred by rebel Chicago artists trying to disassociate themselves from the restraints of New York ideology, and West Coast funk, with roots in pop art, dadaism, and art brut.

Chicago Imagism

In 1966, an exhibition of six young painters, former students of the School of the Art Institute of Chicago, was held at the Hyde Park Art Center. The group went by the unlikely name of The Hairy Who, and it included James Falconer, Art Green, Gladys Nilsson, Jim Nutt, Suellen Rocca, and Karl Wirsum. These artists created

an eccentric body of art that set the stage for an emerging style known as Chicago imagism. The artists exhibited together from 1966 to 1969; their art was inspired by the autonomous styles of Jean Dubuffet, H. C. Westermann, Peter Saul, Philip Guston, outsider and folk art, the art of psychotics, dada, surrealism, African and Oceanic art, popular culture, and the progressive teachings of Ray Yoshida and Whitney Halstead at SAIC.

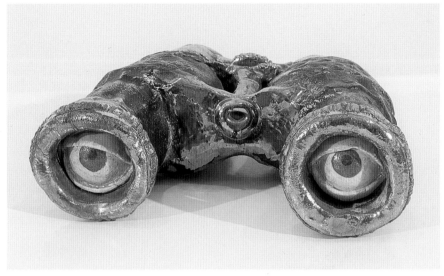

Robert Arneson. *Untitled* (Binoculars), 1964, glazed ceramic, 6 x 6 x 2", George Adams Gallery, New York, © Estate of Robert Arneson, licensed by VAGA, New York.

Although critics characterized the art of The Hairy Who as impudent, cartoonish, outrageous, and grotesque, the young Chicago mavericks considered such characterizations complimentary and as recognition of their impact.

West Coast Funk

The term "funk" was coined by Peter Selz, an art historian from the San Francisco Bay Area, to describe a playfully eccentric aesthetic that evolved into a Northern California art movement. Selz organized an exhibit of funk art at the University of California (Berkeley) Art Museum in 1967, with artists Robert Arneson, William T. Wiley, Roy De Forest, David Gilhooly, Jeremy Anderson, and Clayton Bailey among the exhibitors. The funk artists provoked the art world by making preposterous, farcical, and often wickedly tasteless art, partly as a revolt against abstract expressionism and partly to celebrate their newfound independence. Peter Selz noted that the concerns of these artists centered on senselessness, absurdity—and fun.

With a wry sense of humor and a penchant for caricature and visual punnery, Robert Arneson's influence as an artist and teacher was particularly immense and continues to reverberate in contemporary art. Arneson (1930–92) was trained in the ways of traditional pottery, but he felt stifled by high art's prejudices against ceramic art. In the late 1950s, he fortuitously met Peter Voulkos, a freewheeling, nonconformist who came to teach at the University of California at Berkeley. It was Voulkos's influence that motivated Arneson to abandon making utilitarian pottery and to investigate ways of using clay as a narrative form of expression.

Robert Arneson. *Bob at Rest*, 1981, glazed ceramic, 39 x 26 x 12", George Adams Gallery, New York, © Estate of Robert Arneson, licensed by VAGA, New York.

Arneson, with a new dedication to clay as a fine art medium, was determined to add humor and cartoon figuration to the equation. While teaching at the University of California, Davis (1963–90), with like-minded colleagues Wayne Thiebaud, William T. Wiley, and Roy De Forest, Arneson promoted innovative ways of working with clay that ultimately helped to redefine the field of ceramic art. He urged all students to evolve an independent aesthetic, and instilled in them the importance of ideas, content, and individualism. As museum curator Susan Landauer notes, "If these artists shared a single vision it was bucking the mainstream, a luxury that the remoteness of Davis certainly allowed. It was not so much that these artists rejected 'serious' art per se, but that humor became a strategy for coping with their isolation and celebrating their marginality."[11]

Among Arneson's notable ceramic works is the Old Dog series, which are comic self-portraits. *Bob at Rest* represents a dissident, bad boy who defies mainstream convention, yet solicits attention for his good work, symbolized by the colorful nuggets.

Manifestations in Southern California

Meanwhile, in Los Angeles of the 1960s, Ed Ruscha and Joe Goode based their pop art creations on amusing signage and word structures. California funk artist Ed Kienholz, although best known for creating macabre and disturbing life-size environments, constructed *The Beanery* (1965), an architectural-size re-creation of a West Hollywood bar. Also of note is the work by Los Angeles artist John Baldessari, whose word paintings and mixed-media photography manifest cynical wit.

The Cartoon Style

Today, comic figuration is notably ingrained in mainstream art, with examples found in many museums in America. Among the first artists to employ cartoon figuration in fine art are Red Grooms, Saul Steinberg, H. C. Westermann, Peter Saul, Oyvind Fahlstrom, Philip Guston, and Enrico Baj. Others who have created notable works in this style are Roger Brown, Karl Wirsum, Jim Nutt, Gladys Nilsson, Elizabeth Murray, Roy De Forest, Peter Gianakos, Kenny Scharf, Walter Askin, Sean Landers, Michael Stevens, Mike Kelley, Roger Shimomura, Carrol Dunham, Norman Catherine, Ronald Markman, and Tom Otterness, to name but a few.

Sean Landers. *Career Ego,* 1999, oil on linen, 56 x 47", Andrea Rosen Gallery, New York.

The field of ceramic sculpture has seen a notable influx of artists who have opted to use cartoon figuration as their signature style: David Gilhooly, Tom Rippon, Allan Rosenbaum, Russel Biles, and Janice Farley are among this group. Also of note are the ceramic sculptors who use various styles of caricature that range from the whimsical to the satiric: Viola Frey, Jack Earl, Joe Fafard, Victor Cicansky, Peter VandenBerge, Tony Natsoulas, and Sun Koo Yuh, are representative of this group.

Red Grooms is one of America's leading contemporary artists, and he has been in the forefront of visual humor for over forty years. He is a skillful, multifaceted artist—painter, sculptor, puppeteer, printmaker, filmmaker, and showman—who has been affectionately dubbed by some critics as a cross between P. T. Barnum and Marcel Duchamp.

There's no question that Grooms loves the vigor of the big city, its density, color and texture, hubbub, sounds, smells, and sights. Grooms often uses the term *ruckus* in the titles of his mixed-media art, and he alludes to the cacophony and disorderly

Red Grooms. *By the Shining Sea,* 1999, triptych, enamel on epoxy over Styrofoam,
62 x 124 x 5", courtesy of the Marlborough Gallery, Inc., New York, licensed by ARS, New York.

commotion of the urban habitat—music to the ears of this artist. *By the Shining Sea*
(1999) is an entertaining parody of North American snowbirds that escape winter
by traveling to warmer climes in the south.

H. C. Westermann (1922–81), born in Los Angeles, worked as a woodcutter,
stonemason, and carpenter before turning to the study of art in 1947 at the School of
the Art Institute of Chicago. Westermann is a unique figure in American art, opting
to evolve an artistic sensibility from a personal vision, rather than following the ide-
ologies of prevailing movements. Westermann's experiences as a Marine Corps
gunner on the carrier USS *Enterprise* in World War II and subsequent service in the
Korean War left him with horrific war recollections that radically altered his value
system and work ethos. The comic-tragic characteristic of his art, therefore, is
derived from a cynical wit that points to human anxiety and depersonalization, and

to various satiric impressions about life and the American dream. Mercifully, Westermann's art is leavened with humor and punnery, which precludes it from coming across merely as compassionless derision, but rather as levity and as witty reflection on the human condition.

H. C. Westermann. *The Evil New War God*, 1958, brass, partly chrome-plated, 16 3/4 x 9 3/4 x 10 3/4", Whitney Museum of American Art, New York, licensed by VAGA, New York.

For nearly forty years, Peter Saul has been art's bad boy because of his undeniably funny, but assertive and invariably contemptuous, oftentimes scatological, satire. Saul's paintings, which are beautifully designed and rendered, are a blend of pop art, cartoon figuration (inspired in part by underground comics artist Robert Crumb), and scathing humor that runs riot from the outrageously funny to the queasy and perverse. Saul, with a mischievous streak, pokes and insults with ferocity, whether on issues of consumerism, politics, ethics and morality, religion, art, historical events, or human nature.

Peter Saul. *Clean Money,* 1999, acrylic on canvas, 66⁷/8 x 63", Nolan/Eckman Gallery, New York.

A Return to Figurative Expression

All works of art are inherently expressive because they are psychological extensions of the artist's personality. As such, they reveal aspects of the artist's individuality, temperament, philosophy, and, to a certain extent, the age in which they live.

In Vincent Van Gogh's tortured self-portraits, Edvard Munch's pictorializations of melancholy and inner turmoil, and the exhilaration in the paintings of Joan Miró and Marc Chagall, we see pictures that transcend the impersonal, and ascend to the stature of passionate, subjective representation.

With the advent of abstract expressionism and pop art, however, the nerve center of art shifted from Europe to the United States, and the legacy of European figurative expressionism was all but forgotten in the hoopla of the emerging impersonal styles.

Even with the apparent stranglehold that abstract expressionism had on the art world, there were maverick painters who defected, and returned to figuration. Philip Guston and Robert Beauchamp, both emerging from the school of abstract expressionism, not only returned to the use of the figure in art, but brought with them the techniques of action painting as practiced by Hans Hofmann and Jackson Pollock. Guston and Beauchamp united elements of action painting and figuration into compositions that were at once expressive, funny, and frightening.

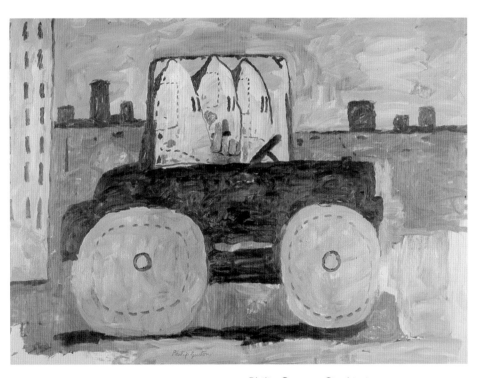

Philip Guston. *City Limits,* 1969, oil on canvas, 77 x 103^1/4", courtesy of the Mckee Gallery, New York.

The content of Guston's canvases addressed societal malaise and everyday violence, whereas Beauchamp's was directed toward self-caricature and revelation, and excursions into the realm of comic phantasmagoria.

Beauchamp's approach was extemporaneous: he used the technique of action painting to pile and swirl paint onto the canvas, and as he progressed, discovered and developed figures in the abstract compositions.

Beauchamp crystallized a style that was midway between realism and abstraction: "I distort and fantasize," he explained. "Realism, for me, gets in the way, because it mirrors surface reality. [Conversely] I do not paint abstractly because it leaves too much out."[12]

Many styles of figurative expression have evolved in the postmodern world, and many of its practitioners have added humor to the mix, as exemplified by the work of the artful jesters in this book. These artists maintain their civil right to be independent, the right to be serious, and to have fun. They, and their precursors, hold open the door of comic figurative expression for the next generation of artful nonconformists.

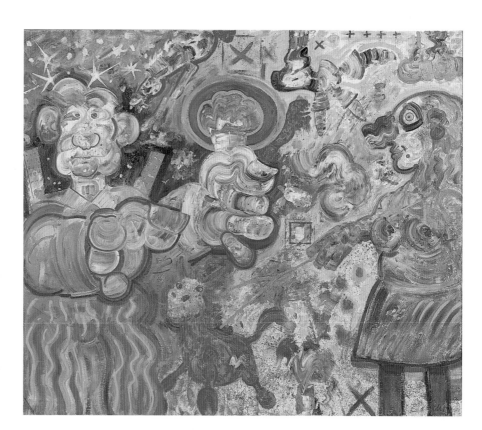

Robert Beauchamp. *Diviner,* 1982, oil on canvas, 65 x 76", courtesy of the David Findlay Gallery, New York, and Nadine Beauchamp.

Let There Be Laughter!

With the reaffirmation of laughter as the best medicine, we have come to realize that humor offers not an escape *from* anywhere, but an escape *to* a different reality, one where laughter helps to elevate us from life's everyday problems and offers a better understanding of ourselves and of each other, while at the same time providing an agreeable means of critique in a postmodern world.

To this end, the artful jesters bring both entertainment and enlightenment with ingenious expressions of lighthearted joy and whimsy, inspired nonsense, and punchy satire. As their ranks steadily grow, and as new aesthetics and directions of visual art emerge in the twenty-first century, there is no question that the ennobling power of humor will play an increasingly important role in our quest to renegotiate our identity and to reinvent our relations to the world.

Visual humor is not only good medicine, but it is truly a democratic phenome-non: it always lets the viewer have the last laugh.

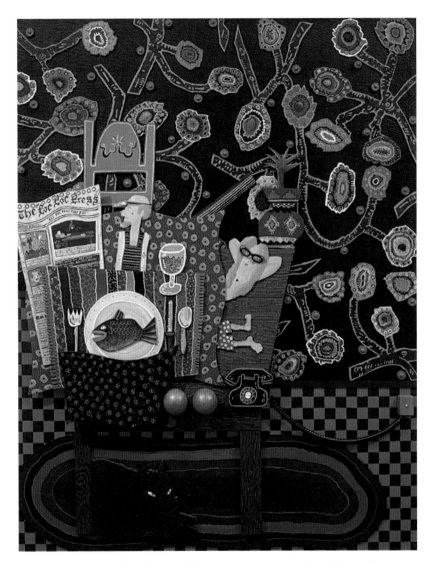

Ronald Markman. *Fish Dinner,* 1981, acrylic on wood, 48 x 38",
courtesy of the artist.

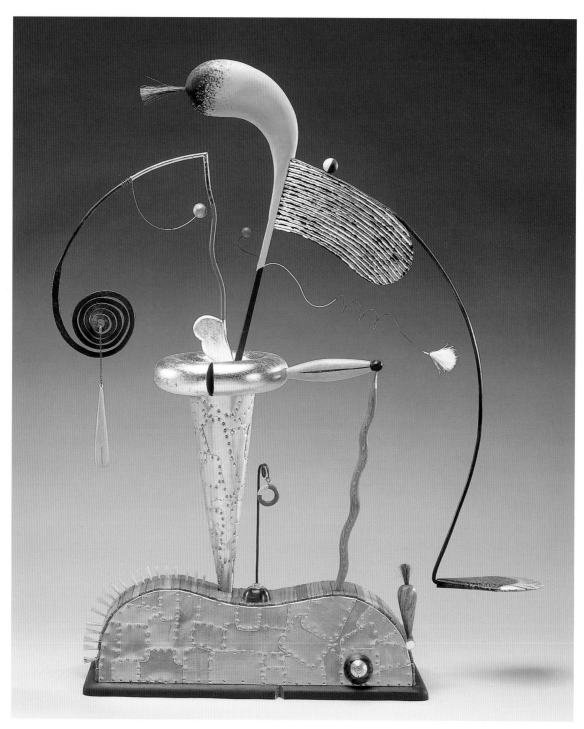

Tommy Simpson. *Miró as Courtesan,* 1993, painted wood, zinc, and wrought iron, 32 x 26 x 6", courtesy of the artist.

portfolio

We didn't know then what
we would come to under-
stand; that when our head,
heart, and body are in the
same place at the same
time, it is the best of
being alive.

—Tommy Simpson

Of Womsters, Poozlers, Snug Rats, and Seers

What can we do today that has any kind of meaning and value? Well, we can search for a means to escape from convention, from ordinariness, and from the limitations of everyday existence. We can learn to play again . . . to break through the ice of habit.

—WALTER ASKIN

WALTER ASKIN

Walter Askin's fictional kingdom is alive with "womsters," "poozlers," snug rats, and seers—terms the artist invented to describe the oddball collection of characters that inhabit his fantasy world and play in his comic soap operas. Isn't it an odd coincidence, however, that the balmy lifestyle of Askin's fictional characters happens to resemble our own? The cartoonlike images and absurd scenarios that distinguish his art prompt both grins and puzzlement as viewers scan his paintings for meaning, which tantalizingly floats just above the surface of his work.

"Humor is not always obvious," Askin reminds us. "It's often subversive and attempts to triumph through the decoy of wit and funniness. Many of the jokes in my art are not of the explosive, boffo type like *The Three Stooges* slapstick comedy, but of the kind that come on slowly—like heat from an old war surplus blanket. Artists who use humor in visual art often create an unreality that appears humorous upon reflection. Therefore, as the viewer's associations broaden, so do the humorous implications."[13]

The bemused and bewildered characters of Askin's visual fiction bring to mind the classic film *One Flew Over the Cuckoo's Nest*, adapted from Ken Kesey's 1962 best-selling novel. From the symbolic point of view, *Cuckoo's Nest* might be seen as a reference to the plight of the creative artist caught in the struggle between independent thinking and acquiescence to conventional dogma. In the movie, Jack Nicholson plays the role of R. P. McMurphy, a drifter and wise guy sent to an asylum for psychiatric examination. He is at loggerheads with nurse Ratched, the authority figure. In one scene McMurphy shouts, "They're telling me I'm crazy over here because I don't sit there like a *#!!! vegetable! If that's what crazy is, I'm senseless, out of it, gone-down-the road, wacko!!" In another scene McMurphy attempts to round up the inmates of the asylum and turn them against nurse Ratched: "God almighty, she's got you guys comin' or goin'! . . . I wanna see hands. Come on, which one of you nuts has got the guts?"[14] Like Kesey's sensibility, Askin's visual humor can be seen as a comic allegory of human existence and as a parody on the plight of the freethinking artist in a conformist society.

"Clearly, it's risky business being an artist," says Askin, "but it's also a freedom, a privilege, a joy, and a downright necessity for me to give my ideas tangible form and to create images that transform my thoughts and states of being. To be an artist is to engage in the wonderfully fulfilling but precarious act of transforming perceptions into propositions."[15]

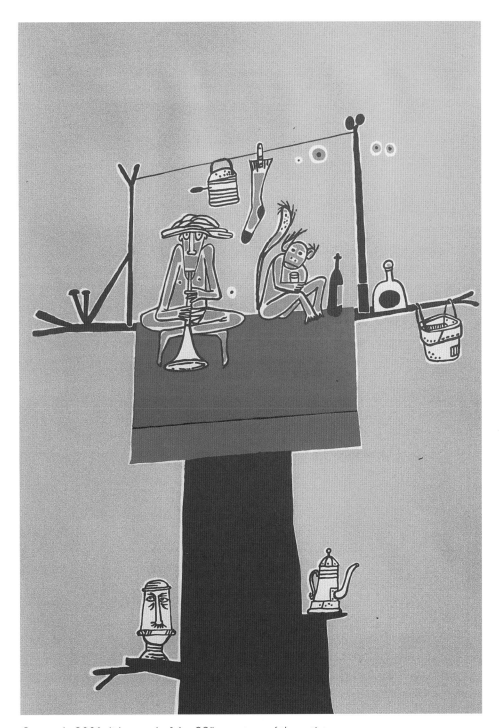

Sampath, 2001, lithograph, 16 x 22", courtesy of the artist.

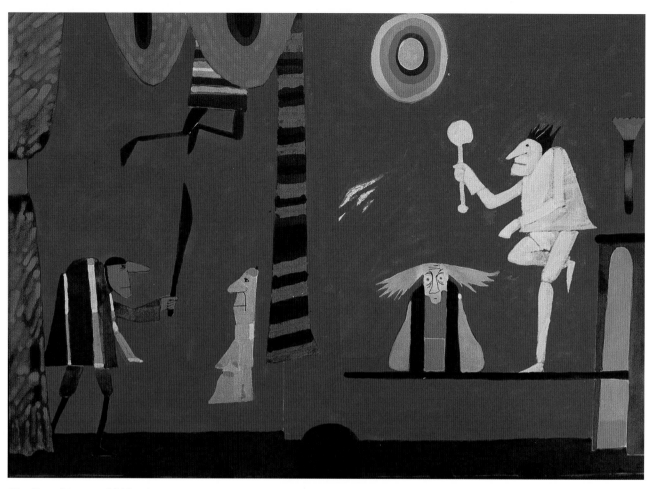

The Four Seasons, 2000,
acrylic on paper, 22 x 30",
courtesy of the artist.

Askin, a graduate of the University of California, Berkeley, also studied at the Ruskin School at Oxford, England. "I discovered that the English have a long tradition of viewing folly and seriousness as an integral package," he explains. "This attitude reflects the sensibility of the Renaissance, wherein laughter was seen as the people's highest spiritual privilege."[16]

Askin's cast of sages and fools provide lighthearted entertainment in a style that resonates with critic Donald Kuspit, who calls it an art that pokes fun at itself and the world and seems to mock the method of its own making, as well as subversively articulating meaning that is customarily repressed or shunted aside.[17]

Walter Askin was born in 1929 in Pasadena, California, where he continues to live and work. He is a founding member and past president of the Los Angeles Printmaking Society and cofounder of the Visual Humor Project, an organization dedicated to the promotion and advancement of visual humor.

A Bailiwick of 'Bots

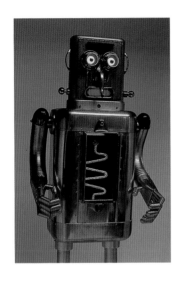

The memory of having lived as a useful object in a past life is embedded in my robot's molecular structure.

— CLAYTON BAILEY

CLAYTON
BAILEY

PROFILE 2

When Clayton Bailey opened the doors of his Wonders of the World Museum in Port Costa, California, to the public in 1976, he had no idea that robotics would one day rule his life and become his passion. Bailey, trained as a ceramic artist, founded the museum mainly as a showcase for his Kaolithic Curiosities—a motley collection of ersatz archaeological finds discovered by his alias emissary, Dr. Gladstone. Among the prevarications displayed in the museum were skulls of legendary creatures such as Bigfoot and Cyclops, along with pseudoscientific papers attesting to the authenticity of the specimens. Also on display were various "fossil testing devices."

Bailey created his first metal robot in 1976 and dubbed it *On-Off, the Wonder Robot.* The six-foot robot was actually a costume that the artist wore in the streets of his hometown to lure tourists to his Wonders of the World Museum. "It was great fun to amuse children and adults, and to shout orders like 'Go to my museum!' I became known as the Pied Piper of Port Costa."[18]

Although the museum closed its doors in 1978, Bailey continued to make life-sized robots from found objects. He haunted scrap metal yards, flea markets, and disposal sites to acquire materials such as old household appliances, dishwashers, toasters, lamps, coffeemakers, stoves, teapots, cookware, and bicycle and automobile parts. Ideas for making robotic creatures came easily as he imagined the odd shapes of various metal objects becoming heads, bodies, and limbs for his anthropomorphic 'bots. His studio came alive with blinking, throbbing, and eerie-sounding mechanical characters that evolved from an aesthetic of whimsy and fanciful engineering. In some cases, they performed double duty as clocks, radios, and night-lights.

"Some of my 'bots became beauties, and others turned into monsters," he recalls. "*Marilyn Monrobot* [1997] is one of my beauties. She's made from reclaimed kitchenware, coffee pots, auto parts, baseball bats, and some other outworn stuff. *Los Angeles Times* art critic William Wilson called her 'estimably tasteless,' but I contend she's the world's most beautiful female robot."[19]

To accompany *Marilyn*, Bailey created *Sparky Robot* (1997) and *Starbot Robot.* Sparky has blinking eyes, a throbbing head, electrical meters that whir and jump, and a high-voltage vapor-powered "digestive tract" in his belly.

Starbot (1997), with its built-in AM/FM radio and stereo tape deck, appeals to viewers. Other noteworthy robot creations from Bailey's workshop are *Futura Robot* (1985), made from an old jukebox and a tape deck, and *Robug* (1980), an oversized kinetic metal insect with flapping wings designed to scare away birds

from the garden. *Robot Dog* (2002) has a built-in motion sensor that causes him to bark ferociously at moving objects—an intimidating presence to would-be intruders.

Unlike the new, state-of-the-art, computer-driven robots with positronic brains—devices that allow 'bots to make creative decisions and to move around, such as Asimo Robo-Dog from Honda Corporation—Bailey's 'bots are of the friendly, old-fashioned, nonintimidating type. They are static robots that just stand still, blink their lights, play music, make impertinent noises, and, in some cases, wiggle parts of their anatomy.

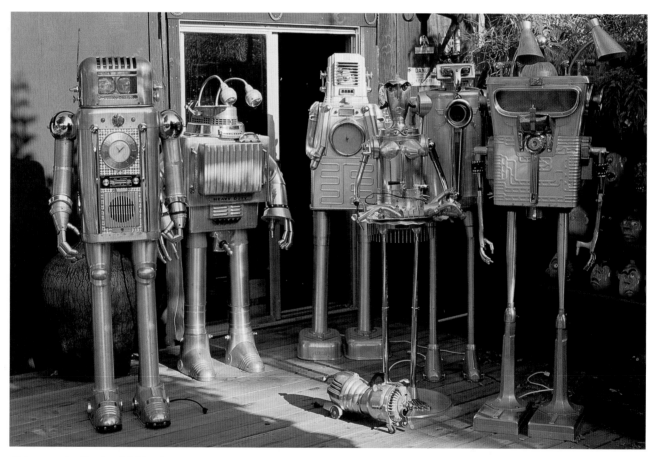

Robots at the Studio, 2000, aluminum and mixed found materials, 72" h, www.claytonbailey.com.

Bailey came to California from Wisconsin in 1967 as a visiting artist at the University of California, Davis, at Robert Arneson's request. "Bob helped me a lot by bringing me to California," he says, "and I knew right away that I should move here permanently because the art scene is perfectly oriented toward my inclinations."[20]

Clayton Bailey was born in 1939 in Antigo, Wisconsin. He is professor emeritus of ceramics at Hayward State University, California, and resides in Port Costa, California.

A

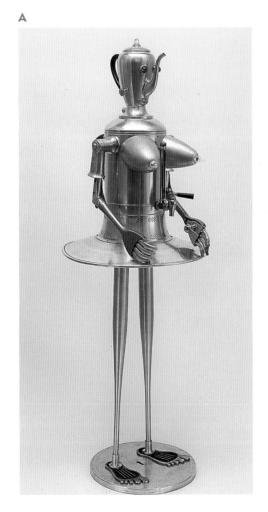

B

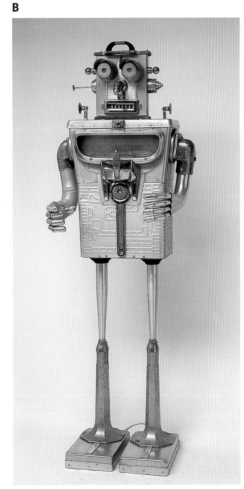

A *Marilyn Monrobot,*
1997, aluminum,
chrome, rubber, plastic,
and light, 62" h,
www.claytonbailey.com.

B *Alien Robot,* 1985,
aluminum and sound-
activated light, 75" h,
www.claytonbailey.com.

Bricolage and Hot Glue

You might say I make feel-good, ecologically friendly art.

— JERRY ROSS BARRISH

JERRY ROSS BARRISH

PROFILE 3

Jerry Ross Barrish is a *bricoleur*—an improviser with a talent for turning beach detritus into mythic objects of art. Bricolage, notes Claude Lévi-Strauss, popular French structural anthropologist, is the calculated use of whatever happens to be lying around, so myth is both rational and improvisatorial.

Sculptural art made by an additive process became a major art modus in the twentieth century. It distinguishes the *assemblages* of Claude Dubuffet, the *fragmentations* of Enrico Baj, the *combines* of Robert Rauschenberg, the *merz* of Kurt Schwitters, the *accumulations* of Armand Fernandez, the *boxed constructions* of Joseph Cornell, the *tableaux* of Edward Kienholz, and the *collages* of Pablo Picasso and Georges Braque. Although each artist defined his method by a different name, all were kindred bricoleurs.

"I have become completely enthralled with the potential of junk, and continue to be inspired by it," says Barrish. "I love using the hot glue gun like a welding torch to connect the different pieces that tell a story."[21]

A native San Franciscan, Barrish began making art from junk in 1987 after returning from Berlin as an exchange student. During his stay in Germany, he was inspired by the collage tradition established by Kurt Schwitters, one of the first artists to bestow affection on the lost and unwanted objects of consumer culture.

Inspired by European assemblage art, Barrish began collecting junk strewn along the beaches near his oceanfront home south of San Francisco with the notion of recycling it into sculptural tableaus. "I retrieve only plastic, mostly the nonbiodegradable type that environmentalists classify as belonging to the lowest caste in the hierarchy of debris," he notes. "Sometimes I set out to make a particular image and search for certain pieces to complete the idea, but usually it's the serendipitously discovered stuff that dictates what I'm going to do and what it wants to be."[22]

Although Barrish is a successful businessman and a filmmaker, nothing gives him greater pleasure and a sense of purpose than creating figurative tableaus. "Artists play different roles. Some serve as our social conscience, making us aware of the world around us. Some are like journalists and record the times. Some are political, trying to provoke or bring change. Some, like me, are just trying to enrich the quality of life through humor and beauty."[23] Barrish's humor evolves from strong empathy for his subject matter and from a surprising and witty manner of recycling castoffs.

Barrish's sensibility echoes the sentiments of Guillaume Apollinaire (1880–1918), who proclaimed, "It is perfectly legitimate to use found objects as pictorial elements; they may be new in art, but are already soaked with humanity."[24]

Birth of Venus (1992) shows a female figure emerging from a shell. Unlike Sandro Botticelli's painting *Birth of Venus* (about 1480), which depicts the nude Venus emerging from a giant seashell, Barrish's image grows from a seashell look-alike—a baseball glove. "I'll leave it to the viewer to decide whether I'm making an homage, or making fun—or both," says Barrish.[25]

"In *Marlene* (Blue Angel) [1992] I've tried to capture the essence of the legendary Marlene Dietrich. I fell in love with Marlene the moment I first saw her in the 1929 flick *Blue Angel.* In the film she plays the fickle cabaret singer Lola who 'keeps falling in love again,' but, of course, she can't help it."[26]

In sum, the bricoleur is both mechanic and poet, an artist whose assembled constructions are provocative because of their witty and synergic assembly and because of their metaphoric potential. "There's always a sense of magic when a piece is completed," says Barrish, "yet I must admit that sometimes I really don't understand how it happens."[27]

Jerry Ross Barrish was born in San Francisco in 1939. He graduated from the San Francisco Art Institute and resides in Pacifica, California.

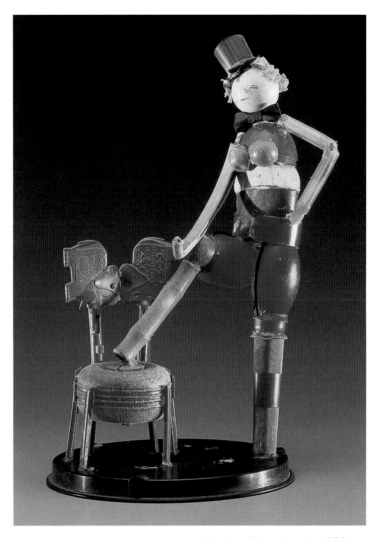

Marlene (Blue Angel), 1992, mixed media, 11³/₄ x 9 x 7", courtesy of the artist, photo by Daniel Oshima.

OPPOSITE: *Birth of Venus,* 1992, mixed found materials, 11³/₄ x 5 x 4¹/₂", courtesy of the artist, photo by Mel Schockner.

Barnyard Brouhaha

Mark Blumenstein is living proof that one man's trash is another man's treasure, that discarded objects left to rust on a junk heap can, with a little help from a resourceful artist, become whimsical art forms.

Blumenstein, born and educated in Philadelphia, swapped the frantic pace of city life at the age of twenty-nine for the peaceful existence of country living. He moved to West Virginia, after having spent many weekends there exploring, hiking, and rock climbing in various parts of the state. But it wasn't until he bought property with a log cabin on it that he discovered something else that brought about a career change. "When my wife, Terri, and I first arrived at our farm in Greenbrier County in West Virginia," says Blumenstein, "there were heaps of junk all around—rusty scrap metal and farm equipment, and some derelict vehicles and trucks left behind by the previous owners. I remember saying to myself, cut this junk up and haul it to the scrap yard! So I bought a set of torches, rented some tanks, and began the process of clearing out the debris. However, as the saying goes, 'A funny thing happened on the way to the forum.'"[28]

When Blumenstein carted trash from his property to the junkyard, he found himself scrounging through the junk there and salvaging discarded objects he describes as "American relics destined to become toasters and car bodies." Blumenstein felt that, in a way, he was performing a civic duty by rescuing parts of once-useful American-made implements and farm machines from the crucible of the junkyard smelter. With a comic touch, he proceeded to unite them in absurd ways, giving them new lives as witty and amusing creatures. From a historical perspective, Blumenstein's art—a specialized type of assemblage that involves the welding of discarded metal into sculpture—resonates with the metal sculpture of the Italian artist Ettore Colla (1899–1968), a forerunner of welded sculpture and an artist noted for transforming old farm equipment and implements into abstract constructions.

Blumenstein not only perpetuates the tradition of welded sculpture but, by adding whimsy and wit through his vision of 'toonlike prehistoric critters of fantasy, he also allies himself with Alexander Calder (1898–1976), the maker of playful art toys and kinetic sculpture.

The ideas for making metal creatures and figures develop spontaneously as Blumenstein arranges and welds various combinations of junk. *Mr. Parker Bird*, for example, evolved from the combination of scrap metal and an old castaway

MARK BLUMENSTEIN

PROFILE 4

saxophone. The sculptural idea developed into an amusing visual pun, as well as a reference and tribute to Charlie Parker, arguably the world's greatest saxophonist, affectionately known as "Bird." Interestingly, Blumenstein, like Bird, is appreciated for his innovative improvisations. "*Springasaurus* evolved when I discovered some old metal springs. Wow! I thought; these things are extinct. Just what I need to make an extinct Springasaurus!"[29]

Mark Blumenstein was born in Philadelphia, Pennsylvania. He lives in Alderson, West Virginia.

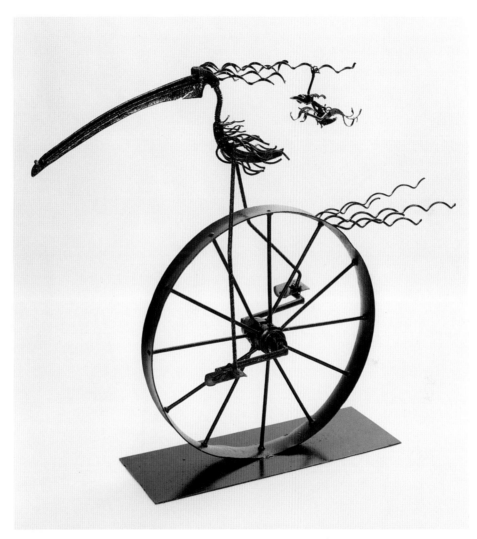

Along for the Ride, 1991, metal wheel, rods, springs, and scythe blade, 48" h, courtesy of the artist.

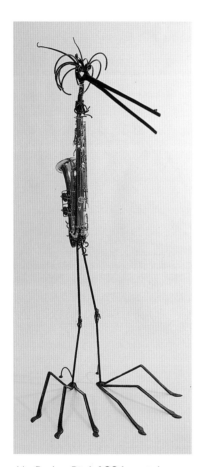

Mr. Parker Bird, 1996, metal
and derelict saxophone, 72" h,
courtesy of the artist.

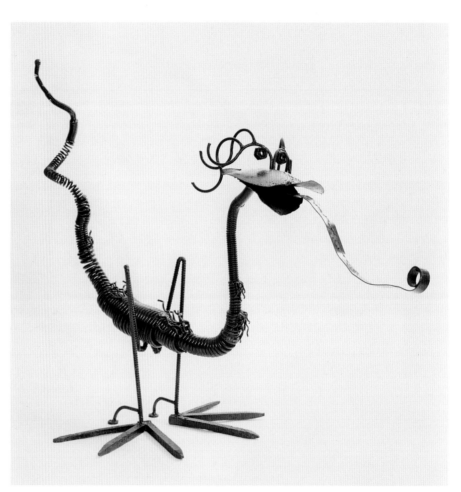

Springasaurus, 2000, metal springs, rods, and spikes, 60" l, courtesy of the artist.

Notes from a Dark Comedy

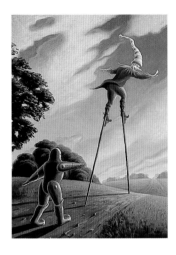

*Everything went wrong
and upside down, but
the nature of things
was reborn.*

—VITSZENTOS
KORNAROS,
17TH-CENTURY POET

MARK BRYAN

PROFILE 5

Mark Bryan's intuitively conceived paintings are like irrational dreams tempered by a comical touch. Clearly, all images derived from the subconscious are ambiguous, yet in spite of their incongruity, the products of Bryan's imagination hint at recognizable underlying thoughts and anxieties.

The Tower (2000), for example, is a surreal painting that shows a lightning bolt striking and demolishing a monumental edifice. In the foreground, a jester flees the devastation on a unicycle. The image carries an obvious reference to Pieter Bruegel's *Tower of Babel* (1563), a painting derived from the story in Genesis 11:1–9 describing man's folly in affronting God and incurring his wrath. Bryan's version entreats the viewer to ponder the recontextualized painting as a contemporary metaphor. Bryan, commenting on the painting, says, "When I first thought about the fool on the unicycle riding away from the disaster area, I realized that the tower is a symbol of man's pride and self-importance, and that the lightning bolt is reality asserting itself."[30]

Bryan's paintings underscore the fact that an extraordinary synthesis can occur when the magical realm of the artist's dreamworld is transfused into the equally magical realm of pictorial reality. This synthesis stimulates the mind to call forth yet another magical realm of subjective reality—the metaphor. Psychologists say dreams are filled with metaphors, and metaphors represent a crossing over of potent thoughts from unconscious to conscious levels of understanding.

From the metaphoric perspective, Bryan's work elicits multiple interpretations. The destroyed tower can be read as the annihilation of stereotypes and antiquated belief systems by updated, contemporary beliefs. The fool is perhaps a wise fool who has possibly gained new insights, and therefore wastes no time in distancing himself from the asphyxiating tenets of outdated dogma.

In *Roberto and the Metal Man* (2000), Bryan again employs the archetypal image of the fool, this time on stilts and seemingly on a road to nowhere, with an obedient robot following close behind. "The meaning of this image is still obtuse," says Bryan. "A man on stilts is a loaded symbol. He's up in the air, vulnerable, and it takes a lot of skill and courage to do this, and the consequences of failure are great."[31]

Sigmund Freud once described dreams as the "royal road to the unconscious," an activity where conscious criticism is abrogated while the irrational mind plays and fantasizes. Carl Jung writes in *Jung on Active Imagination* that the creative process consists of the unconscious activation of an archetypal image that is

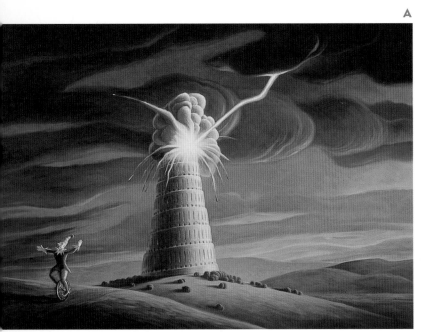

shaped into a finished work. "By giving it shape, the artist translates it into the language of the present and in doing so makes it possible for us to find our way back to the deepest springs of life."[32]

If Looks Could Kill (1997) can be read as a metaphor of human conflict, an image of warfare that has been played out throughout history. It also alludes to temporary domestic misunderstandings in the artist's life. "My wife and I were coming out of a rough patch at the time I painted this picture," Bryan says. "Notice that even the food in this painting is engaged in warfare."[33]

Humorologist C. W. Metcalf says humor and laughter do not exist in the absence of sorrow and tears, but coexist as a balance of sanity.[34] Bryan's iconography, loaded as it is with multiple meanings, has the potential to make us laugh and to think about the frivolities and stupidities committed by so-called enlightened human beings. "Sometimes while I'm sketching," Bryan says. "I often feel like I'm taking notes at a dark comedy, but the play never ends, and I can't go home."[35]

Mark Bryan was born in 1950 in Huntington Park, California. He lives in Arroyo Grande, California.

A *The Tower*, 2000, oil on panel, 46 x 32", courtesy of the artist.

B *If Looks Could Kill*, 1997, acrylic on panel, 42 x 32", courtesy of the artist.

PREVIOUS PAGE: *Roberto and the Metal Man*, 2000, oil on panel, 23 x 32", courtesy of the artist.

The Conversation, 2002, oil on panel, 11$\frac{1}{2}$ x 15", courtesy of the artist.

Torch Bearer for Comic Fantasy

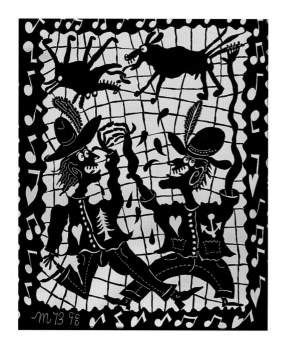

Hell, if you can't laugh, you'll just die crying. So I'm still here making funny stuff.

— MARK BULWINKLE

PROFILE 6

In his younger days, Mark Bulwinkle worked as a welder at Bethlehem Steel Corporation repairing ships—an occupation he thought would last only six months yet went on for twelve years. "And it seemed like seventy,"[36] he notes.

It was at the shipyards that he learned the fundamentals of metal cutting and welding and, in a roundabout way, wisdom about design and composition. As he worked on the ships undergoing repair, Bulwinkle began to give attention to the gaping holes, random cracks, and oxidized surfaces on the rusted hulls of the ships awaiting repair. Their lively interplay of positive and negative form and the oddly exquisite patinas of color and texture fascinated him.

"What really happened to me in that shipyard was that I discovered steel as a potential art medium," explains Bulwinkle. "And from that experience, I learned that making art is never merely about fabricating an 'object,' but about creating an aesthetic of beautiful lines and shapes with the cutting torch. I was never influenced by the traditional paper-cut art from China, Poland, or Haiti; my steel cut-out sculpture evolved by just fooling around with the cutting torch and the metal plate to see what would come out. It was something automatic; the technique came to me as easy as writing with a pen."[37]

Bulwinkle's whimsically frenetic images of critters and figures are filigreed in plate and sheet steel using the plasma (arc) or oxyacetylene cutting torch. His personal work ethos is not motivated by mainstream ideology, but rather by the art of folk artists, cartoonists, surrealists, and certain offbeat innovators who explore an independent vision and are generally considered outsiders.

"Why do I use humor in my art? Well, like most people, I sometimes see my life as a series of minor tragedies, and I think, hell, if you can't laugh at what the world hands you, you'll just die crying. So I'm still here making funny stuff. I don't go out looking for humor or irony; the fact is, it's impossible not to notice it on every street corner.

The first time I started to really think about humor in art was around 1970 when I discovered the San Francisco underground comics. I happened to be living in New York City at the time and went through every San Francisco comic book I

could find at the bookstore on Second Avenue and Eighth Street. That's when I gave up trying to be a painter. I split from New York City and headed straight for the San Francisco Bay Area, where I've been ever since."[38]

Bulwinkle has often been called a folk artist, a designation he considers complimentary. But he also mischievously notes that a distinction between genuine folk art and pseudo folk art is "money—with a capital $."

"You ask what gets me goin'. Human misery, usually. Most recently, I found the misery of Charles Bukowski (1920–94), the American poet, incredibly funny. Why? I dunno. It may be that other people's misery makes me feel a lot less lonely."[39]

Mark Bulwinkle was born in 1946 in Waltham, Massachusetts. He lives in Oakland, California.

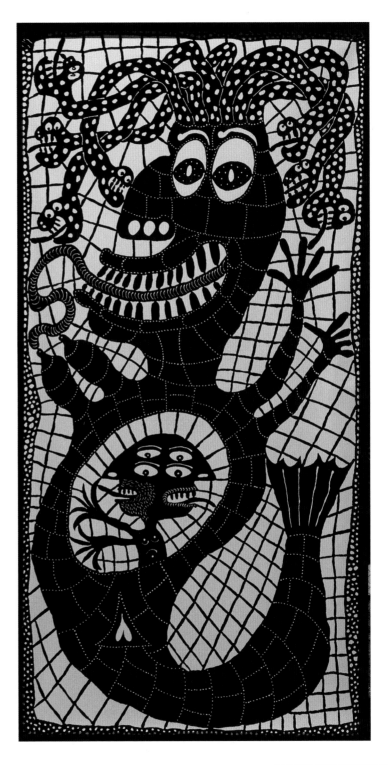

Mermaid, 1997, sheet steel, 4 x 8', courtesy of the artist.

OPPOSITE: *Together,* 1998, sheet steel, 4 x 5', courtesy of the artist.

If the Shoe Fits

TOBY BUONAGURIO

PROFILE 7

Toby Buonagurio's shoe fetish began about thirty years ago and now appears to have turned into a determined, anti-kitsch campaign. Her series of fantasy shoes are visual jokes that spoof tacky and mediocre consumer taste. Ceramics, embellished with gaudy color and glitzy surface ornamentation, is her medium of choice, and thus treated it seems like an ideal medium for conveying her tongue-in-cheek commentary about consumerism and the commodification of culture.

"All of my fantasy shoes are constructed as unique, one-of-a-kind pairs. They are asymmetrical in form, color, surface, and imagery, and built as mirror images of each other,"[40] says Buonagurio.

As metaphors of mediocrity, Buonagurio's excessively ornamented shoes tweak the consciousness of the lowbrow and the highbrow, as well as that of the "nobrow," the populace in between. "I see the out of scale and recontextualized images of my shoes as performers, playing a role in an implied narrative," she explains. "Each pair is fashioned so viewers can clearly distinguish the target, even if it happens to be themselves. . . . *Double-Gun Shoes* [1978] was inspired by the gaudy life of Las Vegas—its cacophony of dazzling lights, glittery surfaces, wrap-around, rhinestone-studded dice, wheels of fortune, and the scantily clad women wearing sexy pistol-stiletto heels that send an implicit message that says, 'You can look but you better not touch!' *Flamingo Shoes* [1974] is the first pair of art shoes I made that incorporates castings of found objects. In this instance, I made clay castings of tacky 1940s flamingo souvenirs of Miami for the heels of the shoes."[41]

Buonagurio's comic irony and caricature are not confined to fantasy shoes. Other subjects that have appeared in her art beginning in the 1970s are science fiction robots, mutant creatures, souped-up hot rods, quasi-religious monuments, and flamboyant self-portraits. "I do not confine my ceramic art to any single subject matter, but instead embrace a wide range of thematic interests filtered through humor and irony. Whatever the imagery, it invariably undergoes physical and contextual transformation. The final metamorphosis takes place with the application of bright, low-fire glazes, fluorescent-colored paints, metallic lusters, rayon flocking, glitter, and rhinestone-studded surfaces."[42]

Toby Buonagurio was born in 1947 in the Bronx, New York, where she continues to live and work. She is professor of art at the State University of New York, Stony Brook.

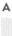

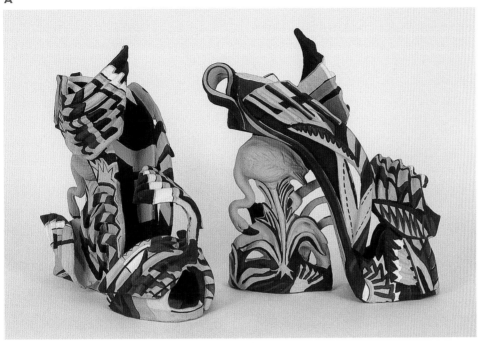

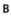

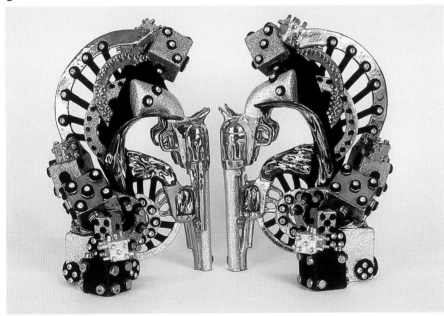

A *Flamingo Shoes,* 1974,
ceramic with diverse surfaces,
13 x 6$^{1}/_{2}$ x 11" (each shoe),
courtesy of the artist, photo
by Edgar Buonagurio.

B *Double-Gun Shoes,* 1978,
ceramic with diverse surfaces,
15 x 9 x 6$^{1}/_{2}$" (each shoe),
courtesy of the artist, photo
by Edgar Buonagurio.

OPPOSITE: *Snake Skin Robot
Shoes,* 1980, ceramic with diverse
surfaces, 15$^{1}/_{2}$ x 5$^{1}/_{2}$ x 12"
(each shoe), courtesy of the artist,
photo by Tom Rose.

A Practical Synthesis

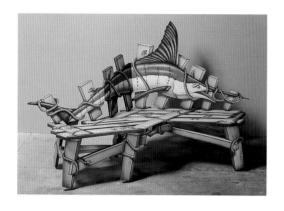

John Cederquist's art furniture is an eccentric blend of art and practicality. The skillfully crafted cabinetwork that emerges from his studio is outrageous and spirited in design, and it appears to be inspired by both the rich legacy of woodcraft and the artist's fascination with surreal art and the comics.

The presence of art furniture in art galleries and museums not only signals the growing presence of this unique art hybrid, but also celebrates the acceptance of aesthetic hybridizations that unite fine art, crafts, practicality, and humor. Furthermore, it celebrates the extraordinary rise and transformation of the craft movement in America.

John Cederquist uses his craft to set traps for the eye, and to rejoice the mind when it discovers that its senses have been fooled.

—ARTHUR C. DANTO, ART CRITIC

Art furniture, because of its functionality, has the propensity to insinuate itself into our daily lives more deeply and pervasively than many of the so-called fine arts, notes Peter T. Joseph, collector and former New York gallery director.

But should this genre of artful expression be classified as art or furniture—or both? Although the avant-gardist would answer affirmatively to all aforementioned classifications, there are critics who would argue that the question demands further discourse. Critic Arthur C. Danto is right to suggest that we look beyond such issues and toward those that broach a bigger concern—the realm of meaning.

Every aesthetic object has the potential of metaphoric significance. Cederquist's art furniture unquestionably rises to that potential insofar as its qualities resonate with our times; they are brash, unconventional, enterprising, and eminently innovative.

Cederquist revises the classic tradition of furniture design with tongue-in-cheek humor, and he completely disregards antecedent tenets that restrict furniture design to the notion that form must follow function. Instead, he charts a novel course that brings furniture into the realm of fine art, with its concomitant emphasis on psychological and aesthetic functionality. Thus liberated, art furniture such as Cederquist's aspires to be sources of not only utilitarian function, but of emotional and intellectual gratification as well.

Cederquist's themes are derived from sources such as Japanese woodblock design, American classic cartoons (*Krazy Kat*, *Mighty Mouse*, and *Popeye*), Rube Goldberg's absurd how-to inventions, Hollywood stage sets, surreal art, and optical illusions like those by M. C. Escher, René Magritte, and Salvador Dalí.

JOHN CEDERQUIST

PROFILE 8

Steamer Chest II (1995) is a cartoon-inspired chest of drawers that echoes Magritte's famous painting *The Treachery of Images* (This Is Not a Pipe) (1928). Similarly, Cederquist could have named his work This Is Not a (Steamer) Pipe, since it is not a real steamer pipe that encircles the cabinet, but a reproduction of a steamer pipe made of wood and paint, and the pipe is not a pipe at all, but a chest of drawers.

Unquestionably, the interplay between illusion and reality is the primary stimulus to Cederquist's creativity. His clever subterfuge invariably bewilders first-time viewers. *Steamer Chest II*, for example, usually succeeds in baffling viewers looking for the pull-out drawers of the misshapen cabinet. Still, even with its devilish deception and obstreperous presence, *Steamer Chest II*, like the rest of Cederquist's creations, lifts the spirit and brings much-needed fun and lightheartedness to the art of fine furniture design.

John Cederquist was born in 1946 in Altadena, California. He lives in San Juan Capistrano, California.

OPPOSITE: *Folding Fish Bench,* 2000, various woods and ink, 46 x 88 x 42", Franklin Parrasch Gallery, New York.

Steamer Chest II, 1995, various woods, resin, and dyes, 71 x 39 x 18", Franklin Parrasch Gallery, New York.

Taking Art Down the Garden Path

Life begins the day you start a garden.

— CHINESE PROVERB

Canadian artist Victor Cicansky is a man of diverse talents—artist, teacher, humorist, and gardener. "I am utterly fascinated by the world of the garden," he enthuses. "This is the world that inspires my art. The natural rhythms of growth, decay, and renewal that can be observed in the marvelous spectacle of nature are the primary stimuli for my artwork. The plants that germinate and grow to fruition, and the knowledge that they are the basis of all things and are indispensable for human existence excite me. Because all living things are in various ways connected and interdependent, I try to understand the mystery of nature's workings through empathic projection. What would it be like, I ask myself, to *be* a plant growing in the garden? What would it be like to be a cucumber, a tomato, a dandelion, or a Granny Smith apple growing in a prairie garden? The sense of wonder that I experienced as a young boy lying in a freshly ploughed furrow still leaves me awestruck at the magnitude of nature's endless biotic enterprise. Unquestionably, the garden not only enriches my spirit but provides means and meaning for my creative expression."[43]

Cicansky's visual humor pivots on empathy and comic transposition—and a nod to Paul Klee's attention to the emotional life of plants. Like Klee—the Swiss painter, graphic artist, and theorist who created whimsical images derived from the study of plant morphology—Cicansky employs his imaginative wit and humor as well as his considerable talents in ceramic and metal sculpture to create an "in-between world," a world between the reality of nature and of human imagination. Objects of nature's reality are thus transfigured into constructions of fantasy: a carrot garden mysteriously grows on a living-room sofa; the handle of a garden spade sprouts leaves and fruit; amorous, anthropomorphic vegetables exchange hugs and caresses; and a gardener, sitting in an overstuffed chair with a harvest of vegetables around him, metamorphoses into a harmonious blend with his vegetables.

Cicansky says his creative process goes something like this: "I see an image in my mind's eye—a hefty turnip sitting in an armchair, for example—and I go to my studio to transform it into an object that has never existed before. As I turn the idea over in my head, I get new insights and understandings that fuel my imagination. The challenge for me is to figure out how to create an object that reflects my original idea."[44] By employing creative thought processes that pivot on transposition

A

(mixing and matching disparate elements), metamorphosis (making forms grow into strange opposites), and hyperbole (wild exaggeration), Cicansky, like Klee, discovers images by looking beyond nature to find structures that although motivatived by the visible, are transfigured by the lure of the inscrutable.

Victor Cicansky was born in 1935 in Regina, Saskatchewan. His fondness for visual humor was invigorated at the University of California, Davis, while studying for an MFA and serving as assistant to Robert Arneson in 1970. Since then, he has been a member of the faculty of fine arts at the University of Regina. He continues to live in Regina.

B

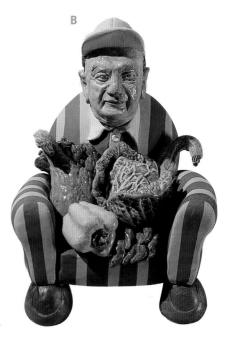

A *Garden Spade,* 1997, wood, acrylic, and paint, 99 x 63 x 24", courtesy of the artist.

B *October Squash,* 1984, clay and glazes, 15 x 13 x 12^1/$_2$", courtesy of the artist.

OPPOSITE: *One Night Stand,* 1994, clay and glazes, 7^1/$_2$ x 12^1/$_2$ x 8", courtesy of the artist.

Natural Instincts

Man is a strange animal, he doesn't like to read the handwriting on the wall until his back is up against it.

—ADLAI STEVENSON,
POLITICAL STATESMAN

ANNE COE

PROFILE 10

Anne Coe's paintings are stylistically akin to magic realism, a post-expressionist style that is realistic and rooted in the everyday but with overtones of fantasy and myth. In Coe's case, it is also possessed of a disquieting humor that satirizes a society that lacks empathy for its environment and wildlife—a vision that clearly establishes the artist as a passionate conservationist.

Her amusing paintings of eccentric animal behavior—coyotes drag-racing pink Cadillacs; gargantuan Gila monsters tearing up dam sites; and wild bears frolicking in ice-cream parlors—are whimsical displays of comic fantasy. Yet behind the facade of humor lies a serious dedication to ecology, wildlife, and bioethics.

"Yes, I'm a regional painter who uses realism and expressionism tempered with humor," she admits. "The side of me that comes out first in my art is the stand-up comic, but there is also the darker side that needs to be vented."[45] Through her art, Coe has become a well-known advocate for ecological health, a crusader for animal rights, and a booster for a sustainable environment. Coe's images speak volumes against the reckless commercialization of natural resources.

Her visual sermons, sweetened with wit and humor, permit her to communicate in a manner that might otherwise be ignored. She has learned from experience, she says, that no one shoots the messenger who makes them laugh.[46]

In *Earth Daze* (1989), Coe addresses the issue of urban sprawl and its negative impact on wildlife. Two coyotes at the edge of a hill howl at the approaching deluge of humanity—a virtual steamroller of concrete, asphalt, automobiles, and pollution that threatens to usurp their tranquil habitat.

Another Western Water Project (1993), a droll commentary on toxic environmental pollution, speaks of the dire consequences of irresponsible nuclear testing and waste management and of the mismanagement of water resources. A rampaging Gila monster (a mutation caused by radioactive fallout?) wreaks havoc at Boulder Dam in retaliation against human negligence. "There's always an element of comic irony in the interface between wildlife and humans," says Coe, "but we must always be aware of the potentially tragic consequences of such confrontations because it's invariably tragic for the animal who steps into human space."

"I don't feel like I am a prophet of our times," says Coe, "but rather a hand-maiden of the prophets. I take what they say about an important event and try to make it timeless and universal through my imagery. The only way to do that is with metaphor; otherwise, I would just be painting photographs."[47]

Anne Coe was born in 1949 in Henderson, Nevada. She lives and works in the desert east of Apache Junction, Arizona, at the base of the Superstition Mountains.

OPPOSITE: *Earth Daze,* 1989, acrylic on canvas, 45 x 45", courtesy of the artist.

Zoo-Illogical Society, 1993, acrylic on canvas, 50 x 45", courtesy of the artist.

Another Western Water Project, 1993, acrylic on canvas, 50 x 50", courtesy of the artist.

Emblematic Totems

WILLIE COLE

PROFILE 11

Willie Cole makes his emblematic totems by reassembling household appliances and other utilitarian objects. Hair dryers, domestic steam irons, women's high-heeled shoes, and powder room basins are some of the raw materials he uses to fashion iconic objects in the form of masks, warrior shields, slave ships, and human figures.

With sardonic wit and a great empathy for the travails of his African forebears who were kidnapped and transported to America in slave ships, Cole creates provocative images that are potent symbols of African tribal culture and tell tales of displacement, subjugation, and hard labor. He cunningly transforms the iron so observers can see it the way he does—as the shape of a slave ship and a metaphor of servitude.

Cole's art, humorous because of the incongruous combination of disparate commonplace objects, is also mordantly pungent and recounts a moralist's tale about cruelty and hardship endured by slaves and domestics in early America. "They had to find safety and sanctity inside themselves, or they would not have been able to tolerate such torture," writes Maya Angelou. "Lives lived in cauldrons are either obliterated or forged into impenetrable alloys."[48]

Some of Cole's art indirectly comments on another issue—the widespread appropriation of African art by artists and marketers of craft products. Picasso's use of African design can be seen in *Les Demoiselles d'Avignon* (1907), where the artist created a hybrid image comprised of nude female figures with faces clearly derived from African masks. Unlike Picasso, who borrowed the shapes but ignored the spirit of African art, Cole's art evokes images of African-American myths and honors the spiritual essence and sense of ritual and ceremony inherent in African culture.

In addition to its metaphoric references, some viewers may see Cole's art as visual punnery that recalls the nonsense art of dada and particularly of Man Ray's famous altered found object (*Gift*, 1921)—a steam iron with a row of carpet tacks glued on its flat side. Cole's art not only encourages viewers to free-associate, but to understand that many jokes—whether visual or verbal—often conceal grim and painful subject matter.

Willie Cole was born in 1955 in Somerville, New Jersey. He lives in Mine Hill, New Jersey.

A

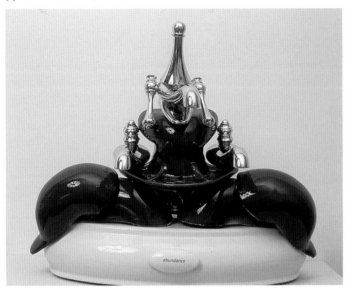

B

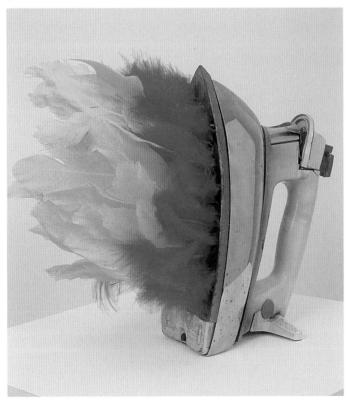

C

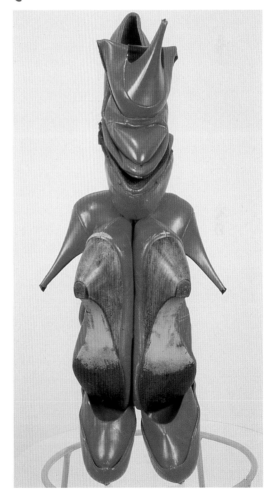

A *Abundance,* 2000, porcelain and metal fixtures, 16¹/₂ x 19¹/₂ x 12", Alexander and Bonin Gallery, New York.

B *Burning Hot I,* 1999, Sunbeam iron with yellow and red feathers, 10 x 7 x 12¹/₂", Alexander and Bonin Gallery, New York.

C *Red Leather Venus,* 1993, sewn shoes, 25 x 8 x 11", Alexander and Bonin Gallery, New York.

OPPOSITE: *Wind Mask East,* 1990, blow dryers, 23 x 24 x 14", Alexander and Bonin Gallery, New York.

The Tender Mock

Warrington Colescott is a master of the tender mock—lampoonery of the Horation order, which is gentle, elegant, and compassionate, yet sharply cast. It is humor-sweetened scorn from a satirist who, without rancor or mean-spiritedness, holds a mirror up to society and says, "Let's take a look at ourselves."

Colescott's softhearted satire may be compared to that of Horace, the Roman poet and satirist (65–8 B.C.), who nurtured deep feelings and concerns for humanity's welfare, conveyed in his moralizing anecdotes and fables that derided the target with empathy and a sentimental streak, rather than with open hostility and venomous derision.

Whatever the preferential method, satirists should not expect anything to happen as a result of their statements, opined critic Harold Rosenberg. "When a clown in a Shakespearean play makes philosophical remarks that go to the heart of the matter, he does not expect the other characters to turn around and begin to function in a different way. He says what he says because his role as a clown is to be a representative of the truth."[49] Colescott concurs, "I can't be too vitriolic and penetrating in my art. Intimidators make lousy artists."[50]

Aside from his early comic satires of infamous American gangsters, Colescott's art is gentle compared to the vitriolic satires by Francisco Goya and George Grosz, and in this sense is closer to the burlesques of the great British caricaturists of the mid-eighteenth and early nineteenth-century, William Hogarth, George Cruikshank, and James Gillray, whose averred purpose was, as an anonymous critic put it, to skewer the amoral, the morally superior, and the morally anaesthetized.

"Satirists thrive when the audience is nervous and needs mirrors to see how they're doing, when they need a little help to understand what's really going on,"[51] says Colescott. Accordingly, his satires focus on issues such as eroding ethics and immorality as in *The Last Judgment* (1987–88), avaricious marketing and consumerism as in *Hunters and Gatherers* (1997), and confused technology as in *The Future on the Line* (1986). His parodies and satires also touch on the inconsistencies and absurdities in art and education and on specific subjects such as exploitation of native people, political and military malfeasance and irresponsibility, and matters of ecology and conservation.

Critic Richard Cox aptly describes the underlying message of Colescott's satires: "Fools, bigots, and even madmen reign in high places, and simple, decent people are at their mercy."[52]

WARRINGTON COLESCOTT

PROFILE 12

56

Warrington Colescott was born in 1921 in Oakland, California. He lives in Hollandale, Wisconsin. He is professor emeritus at the University of Wisconsin in Madison, where he taught for thirty-seven years and developed a renowned program of intaglio printing.

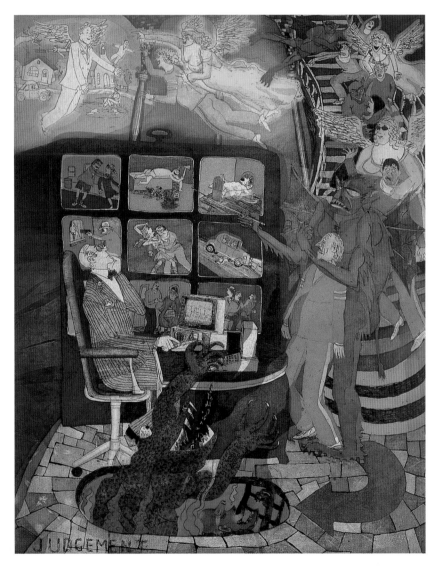

The Last Judgment, 1987–88, intaglio and color relief, 27 x 21³/4", courtesy of the artist.

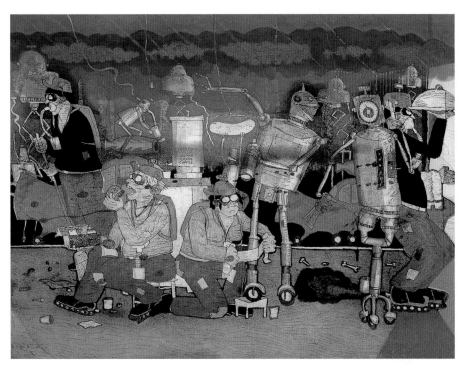

The Future on the Line, 1986, color etching, 15 x 20", courtesy of the artist.

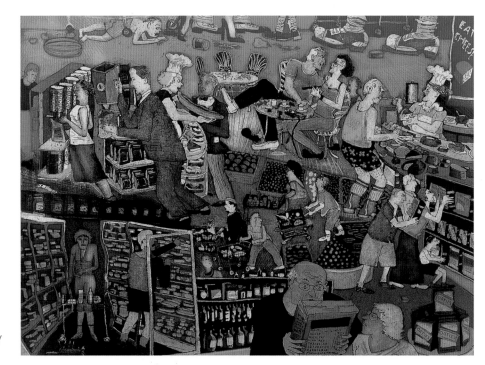

Hunters and Gatherers, 1997, color etching, 17 x 23", courtesy of the artist.

Journeys to the Far Canine Range

ROY DE FOREST

PROFILE 13

Roy De Forest has consistently gone against the grain of mainstream fashion. His explorations have yielded amusing paintings, sculptures, and mixed-media compositions that feature cartoonish figures of humans and animals in scenarios of personal fantasy and myth. Accordingly, he has come to be known as the painter of hermits, grinning dogs, and eccentric travelers on obscure journeys to strange and exotic places. (It is reported that someone once said of De Forest that he translates the human world into dog poetry.)

Why is his idiosyncratic work, created with a lighthearted, faux-naïf style, so compelling? Perhaps it is because it allows us to create our own fiction and prompts early childhood memories of imaginative games that we, too, once played.

To fully appreciate the uniqueness of his paintings—the richness of their color, texture, and paint application—one should not miss an opportunity to view

PREVIOUS PAGE: *Return to St. Helena,* 1997, acrylic and mixed media on masonite, 45 x 50 x 9", George Adams Gallery, New York.

his work in a gallery setting. Each painting invariably satiates with eye-popping color and design; absurdly funny figures and scenarios; and wild, pointillistic patches and globs of textural color—the latter seemingly squeezed directly from the tube.

De Forest's training centered at the California School of Fine Art (now the San Francisco Art Institute) from 1950 to 1952 and at San Francisco State College, where he obtained his undergraduate and graduate degrees. Yearning to distance himself from formalist and abstractionist dictums of the New York School, he

became an active participant in the West Coast's funk art movement of the early 1960s. However, his mature work began to emerge between 1965 and 1982, a period that corresponded with his teaching at the University of California, Davis, with Robert Arneson, William T. Wiley, Wayne Thiebaud, Robert Hudson, and Manuel Neri. The friendship and collegiality that developed between these artists reinforced their mutual need to be independently creative, each firm in the belief that art history is made by artists, not by critics. It is not surprising, however, that De Forest and his coterie of nonconformists were promptly labeled black sheep by the East Coast critics, particularly by *New York Times* art critic Hilton Kramer, who derisively labeled their efforts as "dude ranch dada," and distinguished De Forest's art as "Marx Brothers fauve."

Cavalier by the Sea, 1996, mixed media on paper, 39^1/$_2$ x 52 x 4^1/$_4$", George Adams Gallery, New York.

Such criticism only deepened De Forest's resolve, and as his imagery continued to grow in its playfulness and sophistication, he became increasingly confident in the use of cartoon figuration and humor.

Among the apparent sources of inspiration to De Forest's art are the twentieth-century European masters—particularly the buoyant, faux-naïf expressions of *Der Blaue Reiter* (the German expressionist painters of the early 1900s) and Paul Klee.

Franz Marc's anomalously colored horses, painted in bright, primary hues; Paul Klee's childlike drawings of whimsical blends of aboriginal, surrealist, and cubist art; the joyous spirits of Joan Miró and Pierre Matisse; the art by caricaturists and comic strip artists; and the truly naive art of children and outsiders all, in various ways, resonate in De Forest's creations.

Roy De Forest was born in 1930 in North Platte, Nebraska. He lives in Port Costa, California.

Tomorrow Is Another Day, 1986, polymer and alkyd on canvas, 74^1/$_2$ x 78^1/$_4$", John Natsoulas Gallery, Davis, California.

Oh! What a Lovely War

CARROLL DUNHAM

PROFILE 14

Carroll Dunham's wickedly funny paintings are characterized by the artist's penchant for grotesquerie and cartoon figuration, a combination he effectively uses to picture a comic-tragic world of roguery, mayhem, and relationship hell.

What's appealing about Dunham's cartoonish outpourings is its candor, a quality not unlike the scribbles of young children, which can be characterized as a quintessential blend of symbolic figuration and heartfelt emotion. The rogues and ne'er-do-wells that populate Dunham's canvases are sketched with a faux-naïf style and embellished with smudges, blots, scratches, blobs of acrylic paint, mixed materials, and dissonant color—a combination that sharply accentuates the expression of psychological tension and makes the images virtually blast off the canvases. Dunham's gutsy imagery also draws from art history, particularly Paleolithic cave painting, the art of the Northwest Indians, and the Maya, and from contemporary painters Joan Miró and Philip Guston.

Although his art tilts toward trenchant satire, Dunham does not think of himself as a moralist or social critic. "I never thought about the veils of paint in my paintings as having symbolic reference," he says. "They seem to feel true to me, and they feel like something I have experienced. . . . I am very interested in a certain area of imagery, and I try to work with that, but the imagery runs me more than me running the imagery. My art exists in the tension between irrational, almost goofy things and extremely tight, formal, organized things. That tension is where I live."[53]

The questions regarding Dunham's motivation—whether he intentionally sets out to make disturbing pictures, and whether his muse is energized by conscious or unconscious means—are moot. The art speaks for itself, and it clearly presents a blend of humor and pain. The depiction of planet Earth hurtling through the universe, jam-packed with agitated passengers running amok, pummeling each other with weapons of all descriptions, is an old story retold; it bodes not of optimism but of skepticism and the belief that man is inexorably drawn to primordial, self-destructive urges.

It would be easy to dismiss Dunham's art as dark comedy that points to a hopeless human condition. On the other hand, as critic Richard Kalina points out, his art is perhaps a goad toward understanding human aggression in both personal and social contexts, and how it forms within us, and how we respond to it.[54]

The ancients often taught by antithesis, or contrasting analogy, which was inherent in many of their stories and parables. Similarly, Dunham's tragicomic cartoon follies can be interpreted as moral tales that speak by antithetical parallelism, and point to the opposite of what is portrayed: genuine concern for global harmony and the desperate need for the renewal of faith, morality, and human kindness.

Carroll Dunham was born in 1949 in Old Lyme, Connecticut. He lives in New York City.

OPPOSITE: *Small Planet,* 1997, mixed media on linen, 31^1/$_2$ x 23^1/$_2$", Metro Pictures, New York.

Saddle Ridge, 1997, mixed media on linen, 78 x 54", Metro Pictures, New York.

Bill Looks at Art, Art Looks at Bill

Art is the desire of a man to express himself, and to record the reactions of his personality to the world he lives in.

—AMY LOWELL, POET

JACK EARL

PROFILE 15

Jack Earl is living proof that an artist can survive without sacrificing homegrown values. Although he was formally trained in art at Ohio State University, has lived in urban centers, and has taught at major American art centers and schools, such as the Toledo Art Museum and Virginia Commonwealth University, he prefers the rural life. Away from the city, he can live and work quietly among his friends, the muck farmers of Ohio—those determined tillers of soil in the reclaimed Ohio marshlands.

Earl's porcelain sculptures are poetic representations of the world he inhabits and are crafted with loving care and attention to fine detail. A format that Earl uses for making sculpture, which is also his trademark, is the *dos-à-dos* (pronounced doze-a-doh), meaning "back-to-back." This art form is like a book with two stories beginning at either end; it has a discrete front and back side, each with a contrasting image, and although different, the two seemingly incongruent images prompt the viewer to fill in the conceptual gap through poetic speculation.

Over the years, Earl has earned recognition by art critics for his folksy narratives and poignant slices of life, and he has often been described as a Mark Twain of ceramic sculpture. His amusing anecdotes, set in porcelain, present interpretations of rural life in mid-America, and they are tinged with fantasy and humor. Often, stimuli for his sculptures are derived from snapshots or newspaper and magazine images that he then translates to clay. "I like things that when you look at them you know they were made by people, living somewhere in some kind of environment, and having personal thoughts, personal lives, families and friends," says Earl.[55]

A second genre of Earl sculpture is set in a tableau (tabletop) format. Here, he presents dioramas that vary from the eccentric to the absurd and often feature a character named Bill. Although Bill is a fictional character, he appears to be a composite of Earl's alter ego, farmer friends, and relatives. It is not unusual to see Bill/Earl in fancied environments that crisscross terrestrial reality, history, and mythology.

Earl's fondness for combining prose and art is evident in much of his work. Quite often, diaristic titles in the form of terse phrases, and sometimes paragraph-long prose, are printed or incised on the work's surface.

Jack Earl is a lucky man, observes his biographer Lee Nordness. He lives in a community where the locals unanimously agree that Jack should be able to create anything, even if they don't understand it, as long as it makes him and his family happy.[56]

Jack Earl was born in 1934 in Uniopolis, Ohio. He lives in Lakeview, Ohio.

A *Reading in the Light,* 2002, ceramic, 12 x 6 x 6", Perimeter Gallery, Chicago.

B *Reading in the Light* (side view), 2002, ceramic, 12 x 6 x 6", Perimeter Gallery, Chicago.

C *Bill Escaping Potiphar's Wife,* 1990, whiteware and oil paint, 19³/₄ x 23 x 10", Nancy Margolis Gallery, New York.

OPPOSITE: *Art Looks at Bill,* 1990, ceramic and oil paint, 16 x 19 x 14", Perimeter Gallery, Chicago.

Up Front and Personal

To a toad, what is beauty but a female with two pop-eyes, a wide mouth, a yellow belly, and a spotted back.

—VOLTAIRE, WRITER

JANICE FARLEY

PROFILE 16

New York City artist Janice Farley addresses the controversial issue of female beauty and its fickle criteria, myth, and hype with unique, pun-inspired ceramic art. "Clay has been my medium for almost thirty years," says Farley. "Because of its ease of handling, plasticity, and ability to look like anything one can imagine, it is a perfect material for my ideas and visual expressions, which lately traverse gender issues and cultural stereotypes."[57]

Who can rationalize today's standards for female beauty or understand why seemingly reasonable men and women are seduced by media-driven ideals. The constant and systematic presentation of beautiful bodies on TV, magazines, and billboards has the effect of establishing a "norm" that is beyond the reach of the greater population. In effect, the media says, anything short of being beautiful is aberrant and unattractive.

From the time when man set foot on this earth, the nude female figure has been revered as a symbol of aesthetic beauty, yet today's bizarre fixation on a single body part—the breasts—not only tips the fascination toward the pathological, but contravenes the moral standard that declares women should be judged by the quality of their character and intellect, not by the amplitude of their bra. Whether big- or small breasted, women do not enjoy being ogled or thought of as sexual provocateurs, strictly because of their anatomy.

The question, therefore, continues to be asked "What is female beauty?"

Some may side with Sir James Matthew Barie, a Scottish dramatist and novelist: "Beauty—it's a sort of bloom on a woman. If you have it you don't need anything else, and, if you don't have it, it doesn't matter what else you have."[58]

Others would disagree, but of one thing we can be certain: inner beauty—beauty of mind, spirit, and soul—is distinct from physical beauty, and although it requires hard work to achieve, it is a quality that can be maintained throughout life. Physical beauty is, of course, temporal and fugitive, and it is judged differently by cultures and over time. Contemporary mythologies about beauty are perpetuated largely by media hype and commercial marketers who systematically reinforce the ironic and absurd notion that we can be beautiful by looking like someone else. It is the enlightened person who can look in the mirror and say, "Yes, that's me, and dammit, I like me, 'cause I'm one of a kind!"

Janice Farley was born in 1950 in Brooklyn, New York. She lives in New York City.

Beach Buckets, 1997, clay and glazes, 14 x 9 x 4", courtesy of the artist.

Sundaes, 1997, clay and glazes, 14 x 9 x 7", courtesy of the artist.

Gizmology

*Are you being sinister,
or is this some form of
practical joke?*

—ALLEN GINSBERG,
POET

Gerard Ferrari's obsession for mechanisms and mechanical contraptions, coupled with an urge to spoof what he considers "uncertain advances of science and technology," inspire the fabrication of fantasy machines that he calls "gizmos."

Ferrari opts to make his machines of terra-cotta—a malleable, water-based clay—because he can easily shape the constituent parts that are subsequently coated with low-fire ceramic glaze, kiln-fired, and assembled with epoxy cement.

"My gizmos are visual jokes that question our society's political follies and destructive tendencies," he explains. "*Capitalizing on Punishment* [1999] is a poke at mankind's conspicuous failure to peacefully coexist with his neighbors. The piece is an amalgam of shapes and forms derived from images of deadly devices produced from the advent of history. *Black Hawk Chasing Banana* [1999] is a satire on the Black Hawk helicopter—a beautiful, but deadly, American state-of-the-art military aircraft.

"In order to reconcile my dilemma—my aesthetic appreciation of the visual properties of the aircraft versus my intellectual aversion for it as a lethal weapon—I resorted to making a joke that paraphrases the donkey chasing the carrot theme."[59]

Although Ferrari's art evokes laughter, it also provokes contemplation and brings to mind Sigmund Freud's theory on humor: that jokes have a special aim disguised in humor that attempts to gratify that which is generally repressed or inhibited.[60]

On the one hand, Ferrari makes us laugh with his silly inventions of warfare, yet on the other, he poses an unsettling question: will man's passive acquiescence and ongoing stupidity in matters regarding the proliferation of weaponery annihilate our hopes for future existence as a species? Dutch writer Matthijs van Boxsel hypothesizes that no one is intelligent enough to understand their own stupidity and that culture is nothing but the result of a series of more or less unsuccessful attempts to come to terms with our self-destructive folly.[61] The import of Ferrari's art is unmistakingly clear: the explosive mix of stupidity and intelligence seems to walk hand in hand with technological advance.

Skillful mockery has been called the "champagne of humor," an excellent analogy for Ferrari's satire, a concoction of thought-provoking humor and foreboding.

Gerard Ferrari was born in 1969 in Gallipolis, Ohio. He lives in Poplar Ridge, New York.

**GERARD
FERRARI**

PROFILE 17

Capitalizing on Punishment, 1999, terra-cotta, 14 x 22 x 8", courtesy of the artist.

Black Hawk Chasing Banana, 1999, terra-cotta and low-fire glazes, 13 x 26 x 24", courtesy of the artist.

Pedalling Art

To understand the concept, take one part physical exertion, one part art, and a huge heaping of engineering. Mix them together with chaos and pandemonium and you have Kinetic Sculpture Races.

— J. PATRICK CUDAHY,
PHOTOGRAPHER

When an art buff hears the expression "artist in painting," the image of Jackson Pollock, hunched over an enormous canvas, swirling and flicking paint in a creative frenzy, comes to mind. But if the phrase "artist in sculpture" is mentioned, it is conceivable that Duane Flatmo's name may spring forth, especially if one is aware of the Kinetic Sculpture Races at Ferndale, California. Unlike traditional easel painters who create art at arm's length, Jackson Pollock adopted a method of swirling paint by using large body gestures and by standing astride his canvases, which were laid flat on the floor. Likewise, Duane Flatmo gives new meaning to the term "getting into art," insofar as he not only makes sculpture, but gets inside of it, and races it over land and sea! Since 1969, the tiny town of Ferndale has hosted the Kinetic Sculpture Races, and for the past twenty years Flatmo has been a regular entrant.

A kinetic sculpture is generally defined as something that moves and has aesthetic appeal. Added to this requirement for entering a kinetic sculpture at the Ferndale races are the following stipulations:

A. The entrant must construct a human-powered machine that conforms to course rules and safety regulations as specified in the entry form.

B. The kinetic sculpture must be amphibious, well-built, and capable of traversing a prescribed thirty-eight-mile course of pavement, dirt, mud, and water.

DUANE FLATMO

PROFILE 18

70

Flatmo's aesthetic contraptions have colorful names, such as *Craw-dudes* (1993), the *Sub-Humans* (1995), *The King and Eye* (1999), *Tiki Torture* (2000), and *Tide Fools* (2002). Like dozens of other entries, Flatmo's art-mobiles represent the epitome of surreal art on wheels, and they are comprised of an artful blend of art, humor, and engineering that would please Buckminster Fuller and Salvador Dalí.

To the casual observer who might ask, Why kinetic sculpture races?, volunteer Christine Rising aptly replies, "Because there's a special mystique about the kinetic sculpture race, and these artists are out there having fun!" Aside from the mythomaniacs on wheels, her sentiments are echoed by thousands of exhilarated spectators who have attended the races over the years.

When Flatmo isn't creating kinetic sculpture, he's busy producing paintings, murals, cartoons, and commercial art.

Duane Flatmo was born in 1957 in Santa Monica, California. He lives in Eureka, California.

OPPOSITE: *The Sub-Humans,* 1995, mixed-media kinetic sculpture, courtesy of the artist, photo © J. Patrick Cudahy.

A

B

A *The King and Eye,* 1999, mixed-media kinetic sculpture, courtesy of the artist, photo © J. Patrick Cudahy.

B *Surf and Turf,* 2003, mixed-media kinetic sculpture, courtesy of the artist, photo © J. Patrick Cudahy.

Letting Dreams Take Flight

You see things; and you say, "Why?" But I dream things that never were, and I say, "Why not?"

— GEORGE BERNARD SHAW,
PLAYWRIGHT, CRITIC

JOHN MARTIN GILBERT

PROFILE 19

John Martin Gilbert's wit and humor are evident in visual expressions that range from commercial to fine art. He is an accomplished artist, sculptor, inventor, sometime writer, and visual humorist who delights in creating playful contraptions and a special kind of portraiture.

The meticulously crafted *Airship Paloma* (1995) draws immediate attention for its elegant design, its impeccable craftsmanship, and its absurd pretense as a time machine. "It's an airship inhabited by Leonardo da Vinci and his good friend Pablo Picasso," explains Gilbert. "This airship is known to traverse the heavens, from ancient mythologic times, to infinity, and back again." Pictured aboard the visionary airship are Picasso's mistress, his two young children, the cook, a dog, and a goat. Furthermore, it appears that the good ship *Paloma* has the astonishing power to beam personalities from different time periods to its shipboard environment so distinguished folks from history can enjoy food, wine, and sophistic discussion. "All of the parties on *Paloma* are costume parties," says Gilbert. "Icarus sports a harness with golden-feathered wings and is seen in discussion with the American astronaut John Glenn; da Vinci, dressed in regal purple, shows little Pablo, clad in a Mickey Mouse T-shirt, how to make a paper airplane."[62]

Gilbert's creativity is also revealed in his unique personality portraits. These comic homages take the form of three-dimensional sculpture, and are made of forms and shapes that he fabricates along with found objects. What differentiates Gilbert's portraits from the traditional is that he makes no attempt to capture the facial likeness of his subject but, rather, strives to obtain a symbolic or psychological resemblance by assembling certain components that reflect the individual's vocational and avocational interests. "My intention," explains Gilbert," is to zero in on my subject so precisely that the personality portrait will fit no one else on the planet. After all, isn't a true portrait merely a collection of what we eat, admire, fear, desire, collect, and do?"[63]

Another genre of sculpture that Gilbert originates embodies fanciful inventions that seem inspired by Rube Goldberg, the American cartoonist famous for goofy contrivances and complicated nonsense machines. *Sproutapult* (1990), with a nod to Goldberg, is an absurd device that Gilbert claims will satisfy certain people who, for unknown reasons, have an intense dislike for brussels sprouts. Gilbert's early sculptures were created mainly of balsa wood, and they were painted to

resemble metal, plastic, and other materials. Later, with the need for making larger pieces, he turned to fiberglass. "I can't tell you anything about special techniques with materials because I'm untutored in things like mechanics and carpentry, but somehow I manage to muddle through. And about materials, I'm a pack rat, and have accumulated a large collection of useless items just waiting to be useful. I like to use things for other reasons than their original intent. I'll use a button for a wheel, and a wheel for a button."[64]

Gilbert's philosophy for making art is in line with that of Alexander Calder, the American sculptor who helped create an aesthetic revolution based on whimsical creativity. Gilbert, in the same vein, believes that mirth and laughter not only tickle the funny bone, but expand comic sensibility and help folks break through rigid ways of thinking.

John Martin Gilbert was born in 1926 in New York City. He attended the Art Center School of Design in Los Angeles. He lives in Vancouver, British Columbia.

A *Airship Paloma,* 1995, oak, brass, silk, and plaster, 5 x 4 x 5', courtesy of the artist.

B *The Quest: Personality Portrait of Stephen Cheikes,* 1996, wood, glass, plastic, and ceramic, 30 x 22 x 20", courtesy of the artist.

OPPOSITE: *Sproutapult,* 1990, mixed-media, 12 x 10 x 6", courtesy of the artist.

A

B

Pardoning the Pun

DAVID GILHOOLY

PROFILE 20

David Gilhooly's talent for supplying comic relief for a troubled world is expressed through a variety of art mediums and couched in humor that runs from benign whimsy and parody to mordant satire.

When he doesn't like the way something is going in the world, he simply fixes it up in his FrogWorld and in his other utopian kingdoms, which he creates of clay, plastics, mixed media, printmaking, and graphic design.

Gilhooly's whimsical art is often self-effacing and pokes fun at consumerism, social and political issues, ethics, religion, and mythology. While *Frog Medusa and Her Cruise Dates* (1991) is born of frivolity and of a passion for making comic revisions of history, *Moon Stuck* (1993) strikes at ecological awareness and concern for the preservation of a pollution-free universe. Early in his career in the 1970s, Gilhooly's concern for weight loss prompted a unique strategy for conquering his "overly healthy" hankering for food. "I thought . . . instead of indulging in real food, I'll focus on fake food, reasoning that fantasy food might assuage my appetite for the real stuff. . . . I made everything I could think of that represented big calories, weight gain, and obesity. Soon, my studio filled with enormous servings of 'art food.' It was so luscious I was almost fooled myself."[65]

Gilhooly's FrogWorld is a series of ceramic sculptures he began in the late 1960s. In this fantasy kingdom, frogs and animalia appear in every shape and form and in every imaginable context. Frogs show up in cookie jars, frying pans, soup plates, sandwiches and sundaes, and they go on mythical journeys and take on the personae of famous people. Frog Queen Victoria, Frog Osiris, Boris Frogloff, Frog Napoleon, Frog Medusa, and Frog Benjamin Franklin are among the frog emissaries.

Gilhooly started using sheet plastic for making art in 1983. An impressive example is *Fruit Descending the Staircase, Juicy Fruit* (1985). In this piece, transparent acrylic cutouts of various shapes and colors, along with some commercially made plastic fruit, are arranged so they appear to be tumbling down a staircase. Here, with tongue in cheek, Gilhooly paraphrases Marcel Duchamp's famous *Nude Descending a Staircase* (1912), a dynamic version of cubism in which Duchamp abstracted the image of a nude figure and depicted it in successive movements, as in multiple exposure photography.

Besides plastics, Gilhooly's art extends to drawing, printmaking, and assemblage art. His shadow boxes (or "peep shows" as others have called them) are

designed to hang on walls and are fashioned from miscellaneous materials that he obtains from thrift shops and garage sales. *Forget the Blues, Introducing the Purples!* (1983), is an example of this innovative style of sculptural expression.

David Gilhooly was born in 1943 in Auburn, California. He lives in Newport, Oregon.

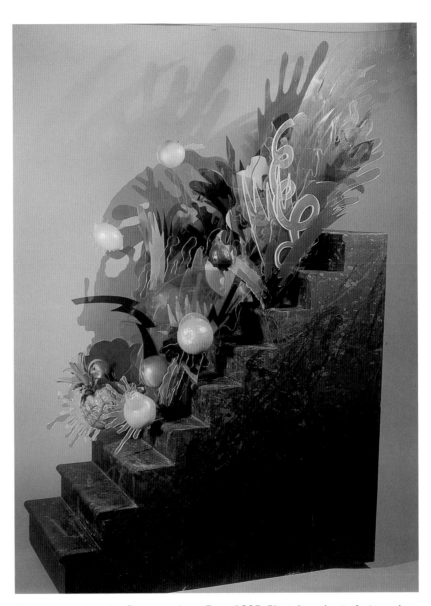

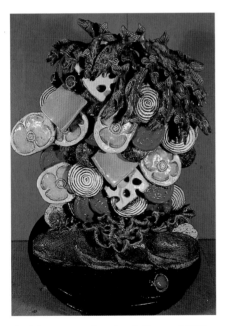

Self-Portrait as Sandwich Fixins, 1983, ceramic and glazes, 16 x 18 x 26", courtesy of the artist.

Fruit Descending the Staircase, Juicy Fruit, 1985, Plexiglas, plastic fruit, and wood, 46 x 34 x 15", courtesy of the artist.

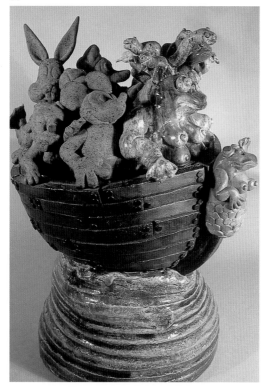

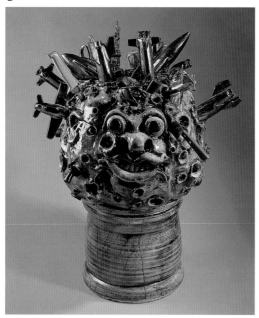

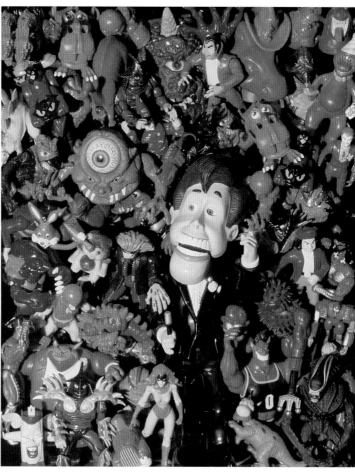

A *Frog Medusa and Her Cruise Dates,* 1991, white earthenware, 18 x 12 x 21", courtesy of the artist.

B *Moon Stuck,* 1993, clay and found objects, 20 x 19 x 27", courtesy of the artist.

C *Forget the Blues, Introducing the Purples!,* 1983, found materials, 24 x 20 x 5", courtesy of the artist.

When Opposites Play

ROBERT HUDSON

PROFILE 21

Robert Hudson's polychrome steel sculptures are assemblages of radically disparate elements, yet the constituent parts are nonetheless splendidly orchestrated into unified compositions that are both aesthetically pleasing and metaphorically provocative.

What are the objectives of the creative artist? In response to this query, Kazantsakis's maxim, or variations of it, may come to mind, and one might add the following: a man's first duty is to the creation of illusions—the interplay of sensuousness and structure, the exploration of the strange versus the familiar, and the indulgence of playful, free-associating fantasy.

With these objectives in mind, one can begin to picture how Robert Hudson addresses the big question as to how and why he makes art. Aside from his brilliance as a conceptualizer and maker of aesthetic unities, Hudson is also an inveterate punster and schemer of mystifying symbols.

The notion of making opposites coexist in art might lead one to think that the process would generate chaos, but for Hudson, the opposite is true; puzzlement is a primary source of enchantment and motivation. An old proverb proclaims that the true origin of art lies in the human longing for enigma, a motto supporting the notion that one of the great pleasures derived from the contemplation of art is the joy of pondering enigmatic images that contain and express different meanings and tend to contradict themselves.

Hudson works in an extemporaneous manner, without benefit of preparatory drawings or models. Instead, he sorts various assembled materials and intuitively combines elements as the work progresses. His love for visual punnery and ambiguous titles is invariably evident in his work. *Metal Mirror* (1996), for example, presents an amusing portrait that evolved from the clever amalgamation of disparate found objects. A metal hook became an eye and nose. The shape of the head is defined in part by a circular saw blade, and the neck and upper body by metal wedges driven into a tree stump. *Blue Antler, Red Wrench, Radiator* (1987) also conceals an amusing profile.

From the beginning of his career in the early 1960s, Hudson cultivated a passion for collecting unrelated materials and objects for his sculptures. He began to paint such materials with bright, polychromatic colors in 1963. A startling effect of color on sculpture is its tendency to emphasize or contradict the volumetric property. Painted planes and shapes become ambiguous and radically alter a

sculpture's appearance, mood, and significance. It was from artists who loved to paint their three-dimensional art—Miró, Picasso, Calder, David Smith, Frank Stella, Manuel Neri, and William Geis— that Hudson developed a respect for the consequential effect of color on form, an outcome that tends to optically transform Hudson's sculptures into extraordinary three-dimensional paintings.

Robert Hudson was born in 1938 in Salt Lake City, Utah. He lives in Cotati, California.

Blue Antler, Red Wrench, Radiator, 1987, steel, stainless steel, antler, cast iron, and enamel, 102 x 57^1/$_2$ x 54^1/$_2$", courtesy of the artist.

PREVIOUS PAGE: *Letter Head,* 1985, unique polychrome bronze, 34^1/$_2$ x 18 x 22", courtesy of the artist.

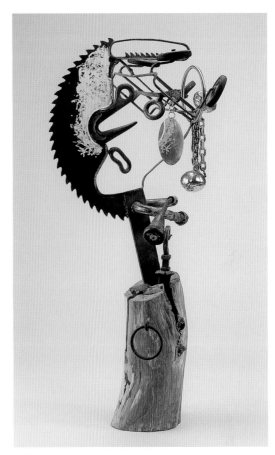

Metal Mirror, 1996, stainless steel, eucalyptus stump, epoxy, resins, and found objects, 54 x 25", courtesy of the artist.

Hot Water, 1982, steel and paint, 91 x 33 x 55", courtesy of the artist.

An Artist's Toy Shop

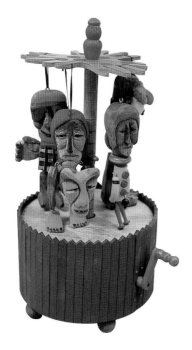

It is never too late to have a happy childhood.

—TOM ROBBINS,
STILL LIFE WITH WOODPECKER

C. W. HURNI

PROFILE 22

C. W. Hurni's art conveys a simple and straightforward message: toys are important throughout our lives. Their forms may change, but their value remains constant. Contrasted to the high-tech doodads disguised as creative playthings, simple and stimulating toys allow us to perpetuate our sense of wonderment by activating that built-in, magnificent toy inside our heads—the imagination.

Hurni's toys are the old-fashioned, crank-operated kind that evokes Early American and European vintage games and comfort toys. They are made of wood, an organic substance that has brought physical and emotional comfort to man throughout the ages. Aside from that, her toys are one-of-a-kind works of art, as opposed to the ubiquitous products that roll off an assembly line.

Hurni was raised on a farm near a small Swiss town. Her father was the village carpenter, and her mother was a homemaker who later learned and profited from the skills of the watchmaking trade. "I loved helping out in the wood shop where my father indulged my curiosity by letting me tinker with tools and scraps of wood. To this day, I love old toys, furnishings, and farm machinery; these things continue to provide inspiration for my inventions. When I immigrated to America, I found New England products and American folk art to be yet another source of stimulation."[66]

The whimsicality of Hurni's sculptures echoes the playful spirit of Alexander Calder and his fanciful animal and circus figures fashioned of wire and wood. "Yes, I am indebted to Calder and his charming art toys," says Hurni. "And to Jean Tinguely for his playful kinetic works, Marisol Escobar and Louise Nevelson for their bold and innovative wood sculptures, to Friedrich Hundertwasser [Austrian painter of colorful abstractions] for his exuberant color, and to my uncle Rudi—my role model who demonstrated the type of dedication required to be an artist."[67] Although differing from her own work and from each other's, all of the artists she admires have one thing in common: a passion for teasing the imagination with an offbeat logic.

In *Self-Portrait* (1998), Hurni presents an amusing and symbolic image of herself. "I like to think of myself as a machine with multiple functions," she explains. "The figures and the silhouetted cutout faces that you see—that's me; the up and down motions that jolt the figures when one turns the little crank at the bottom of the piece refers to the bumpy road of an artist's life. The various threads in the sculpture represent the spider webs in my head!"[68]

C. W. Hurni was born in 1941 in Studen, Switzerland. She lives in Sacramento, California.

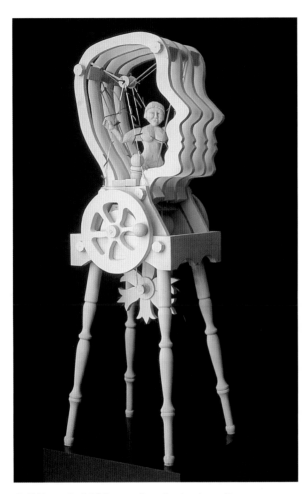

Self-Portrait, 1998, wood and mixed media,
39 x 16 x 16", Solomon Dubnick Gallery, Sacramento,
California.

OPPOSITE: *Merry-Go-Round,*
2000–01, wood, 10 x 10 x 19",
Solomon Dubnick Gallery,
Sacramento, California.

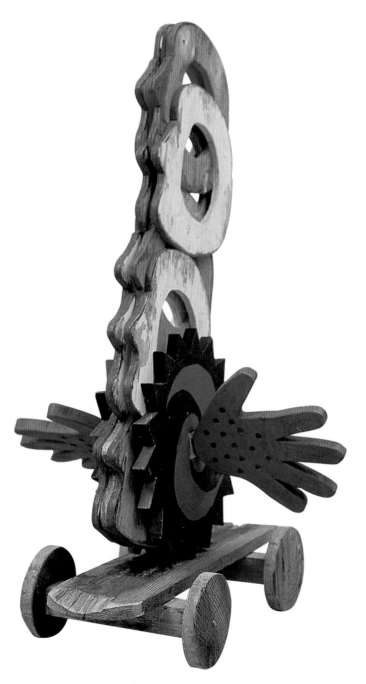

Speed, 2000, wood, 21 x 21 x 35", Solomon Dubnick
Gallery, Sacramento, California.

True Lies

Truth or illusion is not to be found in the objects of intuition, but in the judgments upon them.

— IMMANUEL KANT,
*CRITIQUE OF
PURE REASON*

GUY JOHNSON

Guy Johnson gives new meaning to the old phrase, "A photograph never lies." With a brush technique worthy of a Dutch master and the imagination of a wacky surrealist, he creates images that confound the senses and blur the line between objective reality and over-the-edge fantasy.

There was a time when a news event was believable because there was a picture to back it up. We now know that anybody can augment and rearrange photographs to suit their various benevolent or devilish needs. It is not surprising, therefore, that art critics have described Guy Johnson's paintings as "disturbed portraits." His creative process consists of taking a seemingly innocuous snapshot and seamlessly adding a certain element that radically transforms it into a hauntingly surreal representation.

Johnson's art begins with a search for black-and-white photos from old family albums or daguerreotypes by obscure photographers. He then alters the selected image by incorporating a disparate entity, usually an image from another time frame or context—a raging inferno, a menacing tornado, a coffin, an airship, or other such pictorial elements—thus transforming the originally benign photograph into an image of comic morbidity.

His technical approach is fairly straightforward. "First, I make a collage, reproduce it, then have it enlarged. When I paint on the photostat, that's when I add things, like the tornado."

Louis Meisel, a gallery dealer and the artist's agent, adds further explanation: "[The technique] involves developing the image on a photo-sensitive canvas or paper. The black-and-white image is then painted over in color."[69] The deception is so cleverly done that the viewer has no reason to believe that the manipulated image is anything but real. It is only after the initial double take that the observer detects the trickery and smiles at the artist's altered version of reality.

Johnson's trompe l'oeil ("fool the eye") paintings appear loaded with latent metaphors that beg interpretation, yet the artist offers little help to those who ask him to decipher the cryptic images. "I don't want my paintings to be an answer to the question, What is it?" says Johnson. "Instead, I'll ask you, What do you think it is?"[70]

Guy Johnson was born in 1927 in Fort Wayne, Indiana. He lives in The Netherlands.

Coffee Pot Drive, 1983, oil on paper on aluminum, 27^1/$_2$ x 22", Louis Meisel Gallery, New York.

OPPOSITE: *Self-Portrait,* 1983, oil on paper on aluminum, 20 x 27^1/$_2$", Louis Meisel Gallery, New York.

Mechanical Confections

GINA KAMENTSKY

PROFILE 24

Gina Kamentsky—sculptor, toy designer, inventor, musician, and teacher—has spent the greater part of her work life designing objects for the amusement of children and adults. She was brought up in a household where creativity and the study of science and art were a priority. In her college years she studied industrial design, and upon graduation she found work in the toy industry. During this time she produced a number of award-winning toys for preschool children.

When not occupied with commercial projects, she spends her time creating kinetic contraptions from found metal objects. Her "mechanical confections," as she has dubbed them, have no other purpose than to captivate and amuse the viewer. They have special appeal to folks who had similar toys as children—the kind that were wound up or cranked to make them go, that required no batteries or electronic mechanisms or technical manuals to muddle through; they were just simple, spring-driven, wind-up playthings. Folks who remember the vintage toys of yesteryear probably shake their heads and wonder how such splendid playthings could possibly have spawned the bizarrely complex and confounding "toys" of today. Kamentsky's mechanical contraptions relive the earlier, raw epoch of technology by paraphrasing the vintage crank and wind-up toy that is now most often seen in museums.

Like C. W. Hurni (profile 22), Kamentsky's mission is honest and straightforward: to amuse viewers with funny devices that are whimsical and free of political agenda. However, anyone who insists on searching for metaphoric innuendo will probably regard Kamentsky's series of wind-up toys as a satiric poke at a society in the grip of technology.

Kinetic devices date back to the water clocks of ancient Egypt and Greece and to the town clocks of the Middle Ages when devices with elaborate mechanisms delighted viewers with programmed movements and spectacles. Squeak boxes, vintage toys, music boxes, flicker books, mechanical puppets, marionettes, and the coin-operated automata seen in arcades and museums of historical memorabilia are among some of the other kinetic devices that inspire Kamentsky's art.

The growing popularity of interactive computer games in homes and in arcades points to our latent need for toys that allow us to join in the fun.

Although some critics might place Kamentsky's absurd innovations in the category of neo-dada art, one must remember that dadaism of the 1900s was basically an anti-art and antisocial protest. Kamentsky, on the other hand, has no

axe to grind. She is an amiable, peace-loving person who enjoys making people laugh by creating objects that contribute to their playtime—a need that is ever present throughout life.

Gina Kamentsky was born in 1959 in Plainfield, New Jersey. Her day job is working on interactive animation and toy inventing for the commercial market. She was trained in industrial design at the Philadelphia College of Art, and she lives in Somerville, Massachusetts.

OPPOSITE: *Mystic Monkey,* 1998, wind-up toy, 13 x 6 x 6", collection of Ralph Beckman, photo by Kay Canavino.

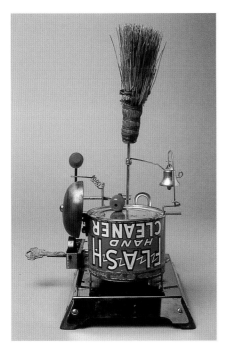

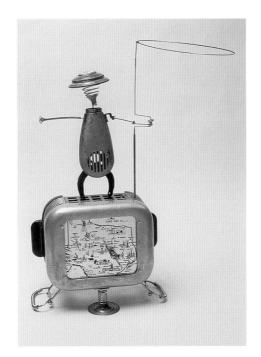

My Man, My Brush, 1999, wind-up toy (makes obnoxious noises), 12 x 5 x 7", courtesy of the artist, photo by Kay Canavino.

Springtime in Texas, 1998, wind-up toy (he swings lariat and rocks on springs), 14 x 11 x 9", collection of Ralph Beckman, photo by Kay Canavino.

Magic Bell Tower, 1998, hand-cranked toy, 20 x 7 x 6", courtesy of the artist, photo by Kay Canavino.

Passport to Parodize

RICHARD NEWMAN

PROFILE 25

Mixed-media artist Richard Newman can take a common subject, say a cultural icon, cliché, ideology, or belief system, and reshape it with caricature and light-hearted humor so that it remains recognizable yet is transformed into an amusing parody.

Parody, whether in literature or visual art, means to imitate for comic effect, and it functions by combining the familiar with the fantastic. It thereby evolves a surreal frisson that can be experienced as nostalgia, amusement, poetic interpretation, or mild satire.

By artfully combining wood, paint, photographs, postcards, and objects of sentimental value, Newman creates three-dimensional narratives that are embedded with biographical anecdotes, which exemplify both personal and universal emotions. *Movie Palace* (Riviera, 1998), for example, is a parody that draws its humor from caricature and tender reminiscences. "In this work, I reflect on the old Saturday afternoon matinees and on the legendary Hollywood stars of the 1940s and 1950s that came to life on the silver screen," says Newman. "The assemblage is named 'Riviera' after the premiere movie house in the city where I grew up. The piece slowly evolved over a period of nearly six years because I was looking for the right materials and images, especially for postcards of old movie palaces throughout the United States, and for movie star arcade cards."[71]

Adam and Eve (1984) is a whimsical parody of a well-known biblical icon. Newman updates it by presenting it as a caricature of a modern-day couple. "It's actually a comical portrait of myself and my wife," says Newman. "The poses of the figures offer a comic twist, since they appear to be partially in flight and somewhat aware of the implications of their choice to taste the forbidden fruit."[72]

Newman's *Kunsthaus* (Art House, 1985) exhibits a biting edge, an example of how parody can move from benign whimsy to cutting satire. Here, Newman's polychromatic wood sculpture pays homage to art history and its role in his life as an artist and teacher as well as to various stylistic concerns and influences. However, an incongruous element gives the viewer pause for concern. On the base of his sculpture, Newman has added some triangular, sharklike forms—a symbol of the Philistines who would tear the house of contemporary art down, given half the chance.

Newman's art springs from the tradition set by twentieth-century artists such as Picasso and from the art of self-taught outsiders like James Hampton, a visionary artist

noted for creating masterpieces from cast-off materials. Man Ray's *Objects of My Affection*, André Breton's *Objet-poèmes*, Joseph Cornell's compartmented boxes, Robert Rauschenberg's combine paintings, and Marisol's mixed-media wood constructions provide additional paradigms for the study of collage, assemblage, and mixed-media art, and they are obvious influences on Newman's art and creativity.

Newman's creative expression is no different from that of any inventor; it issues from making new combinations of data already stored in the mind. In this regard, the ability to jog one's memory, to intuitively free-associate, and to intermingle psychic and aesthetic feelings constitutes a basic methodology and work ethos.

Richard Newman was born in 1938 in North Tonawanda, New York. He lives in Haverhill, Massachusetts.

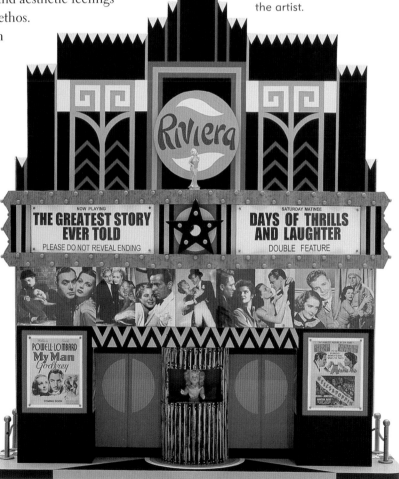

Movie Palace (Riviera), 1998, acrylic, polychromed wood, photographs, postcards, and found objects, 48 x 42 x 16", courtesy of the artist.

Adam and Eve, 1984, mixed media, 36 x 18 x 11", courtesy of the artist.

Artist's Biography, 1996, wood, photographs, found objects, and acrylic, 11 x 11 x 5", courtesy of the artist.

Kunsthaus (Art House), 1985, acrylic, polychromed wood, photographs, and found objects, 82 x 20 x 20", courtesy the artist.

Here's Looking at You and Me, Babe

Oh, life is a glorious cycle of song,
A medley of extemporanea,
And love is a thing that can never go wrong,
And I am Marie of Roumania.

— DOROTHY PARKER,
WRITER

GLADYS NILSSON

PROFILE 26

Gladys Nilsson's paintings overflow with wit and good humor and are chockfull of puns, double entendres, and comic wordplay. With sugarcoated satire and cartoon figuration, her work poignantly addresses sensitive issues. Comic relief springs from a parody of Nilsson's personal life, yet it echoes universal sentiments and emotions. Her work, therefore, is cathartic for both herself and for viewers in general; it expresses a rejuvenation of the spirit and a cleansing of emotions. Simply put, it's the kind of humor that prompts self-reflection and allows us to laugh at ourselves. In a way, her artworks are playlets *(tableaux de mode)* that echo the parodistic spirit of eighteenth-century British caricaturists Thomas Rowlandson and James Gillray.

"Most of what goes on in her art is a fantastic recording of what goes on in her life," comments David Russick, art critic and personal friend of the artist. "Who am I today? Which of my roles—woman, artist, daughter, wife, mother, friend, or combination thereof—shall I examine?"[73]

Whether created from the perspective of social commentary or autobiographical expression (or both), Nilsson's visual narratives are insightful stories of humanity in the context of contemporary life, social customs, and issues.

Although Nilsson's interest in art began in early childhood, her fascination for visual humor ignited when she attended the School of the Art Institute of Chicago between 1958 and 1962. It was there that she met and later married fellow student Jim Nutt, who, along with Nilsson, became a prominent figure in the emergence of a new Chicago art movement.

Nilsson and Nutt, together with James Falconer, Art Green, Suellen Rocca, and Karl Wirsum were founding members of The Hairy Who—a maverick group of Chicago-based artists who helped to initiate the funky art style known as Chicago imagism in the late 1960s.

Nilsson's style of cartoonlike figuration evolved in the 1970s, and she was inspired by artists such as Richard Lindner and H. C. Westermann; contemporary European artists, including Miró, Dubuffet, and Klee; African art, surrealism, and the art of untrained outsider artists. Her work also nods to vintage comic strips—particularly *Thimble Theater*—and to the limpid, elongated figure of Olive Oyl in the *Popeye* comics.

Her cartoonishly styled narratives, rendered in watercolor, tell of cultural preconceptions, biases, and stereotypes and of her own personal life—her creative

Empty Closits, 1993, watercolor on paper, 25³/4 x 20¹/4", courtesy of the artist.

growth and maturation and her view of herself, the world, and the people around her.

Although her pictures reveal private issues, the parodies are of universal dilemmas. *Looking Back* (1999) is a self-portrait in which the artist reflects on her life. On the left-hand side of the painting is the wide-eyed young innocent, excited about the future and what it holds in store. On the right, Nilsson pictures herself in the present, surrounded by tiny drawings of players and events that have affected her life. Interestingly, her style and composition disregard traditional rules of perspective in order to heighten emotional expression. For that reason, images of key players are drawn larger in scale than the images of supporting characters and subplots. *Tilling* (1993) is a narrative about cultivation, perhaps of the artist thinking of herself as a work in progress and a nurturer to those she loves. *Empty Closits* (1993) can be read as a cleansing of the spirit and of truth emerging from the closets of denial.

It has been said that a picture captures the moment, but a scrapbook tells the story. In this regard, a scrapbook—that is, an exhibition of Nilsson's art—reveals much about the artist's personal life. As David Russick observes, "Nilsson's work gives up information a little at a time. Viewing her paintings over the years is like peeking into her family photo album. Her work rewards those who look closely, and carefully."[74]

Gladys Nilsson was born in 1940 in Chicago, where she continues to reside.

PREVIOUS PAGE: *Looking Back,* 1999, watercolor and gouache on paper, 41³/4 x 29⁵/8", courtesy of the artist.

Tilling, 1993, watercolor on paper, 22 x 15", courtesy of the artist.

Veggie Vernacular

Plant forms have been used throughout history to embellish furniture. I want them to be furniture!

— CRAIG NUTT

Inside the persona of Craig Nutt, a seemingly unassuming Southern gentleman and highly respected wood craftsman, lives an incorrigible punster who regards the common garden vegetable as the fountainhead of comic inspiration. "Indeed, much of my work, forgive the pun, is rooted in the garden," says Nutt. "It started out as whirligig sculptures that looked like flying vegetables, and developed into fantasy furniture."[75]

Craig Nutt is a consummate craftsman who gives meticulous attention to every detail of his work. In making art furniture, he begins by roughing out the basic shapes on the band saw and lathe, and then he defines the shapes (such as the cayenne pepper legs) with sharp-edged woodworking tools and rasps. The forms are further refined on a drum sander, then with fine sandpaper, and finally painted with artist's oil paints to achieve the ultimate trompe l'oeil effect.

Nutt's *Banana Pepper Cabinet* (2001) exemplifies trompe l'oeil at its best in art furniture design. The wood cabinet not only has features that resemble real vegetables and fruits, but is also aesthetically beautiful with erotic overtones, and comically amusing in its guise as furniture.

Nutt's incentive to make flying vegetables originated from an unlikely incident. "One day, back in 1988, while working absentmindedly in my studio and half listening to the radio, my ears perked up when I heard the then-presidential candidate George Bush utter the phrase, 'I will never use food as a weapon.' I stopped and wrote the words on the studio wall, thinking first of the seriousness of the statement, and then wondering whether the presidential candidate had any idea that his utterance could be taken as a double entendre."[76] Before long, Nutt had amassed a veritable air force of comestibles—*Airborne Acorn Squash* (1989), *Ground Launch Goober* (1989), *Carrot Bomb* (1989), *Tactical Tuber* (1989), and *Golden Bantam Bomb* (1989), and others.

Nutt's amusing flying vegetables are three-dimensional whirligigs designed for pedestal display. Placed outdoors on a breezy day, the propellers will spin as the whirligigs orient themselves to the wind. The fact that they don't actually fly is inconsequential; the important thing is that they evoke the *idea* of flying, along with whatever other provocative thoughts and fantasies arise in the mind of the viewer.

Craig Nutt was born in Belmond, Iowa, in 1950. He lives in Northport, Alabama.

A

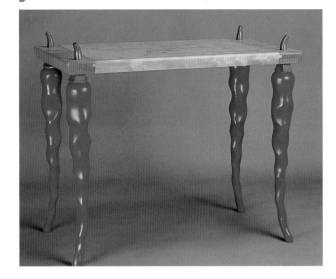

B

C

D

A *Tactical Tuber,* 1989, oil on carved wood, 22 x 15 x 21", courtesy of the artist.

B *Cayenne Pepper Table,* 1989, inlaid birch, lacquered wood, and oil paint, 26 x 30 x 17", courtesy of the artist.

C *Tomato Table,* 1996, oil on wood, inlaid top, 26 x 23 x 23", collection, Columbus Museum, Columbus, Georgia.

D *Banana Pepper Cabinet with Seeds and Fruit,* 2001, painted wood, 81 x 17 x 17", collection of the Corcoran Gallery of Art, Washington, D.C., photo by John Lucas.

OPPOSITE: *Ground Launch Goober,* 1989, oil on carved wood, 24 x 12 x 22", courtesy of the artist.

Bric-a-Brac and Baroque

Dare to be naive. The ability to see things in a fresh way is vital to the creative process.

— DANIEL GOLEMAN,
THE CREATIVE SPIRIT

JUDY ONOFRIO

PROFILE 28

The joy that Judy Onofrio derives from creating mosaic-encrusted assemblages is complemented by her love for collecting bric-a-brac from garage sales and flea markets. It is from such sources that she obtains buttons, beads, costume jewelry, shells, trinkets, fake fruit and flowers, ceramic tiles, and plates that she uses to make her colorful sculptures.

Onofrio, basically self-taught, finds inspiration in the art of folk artists and other self-taught artists who make visionary environments. Among her favorites in the latter group are Antoni Gaudí (Parque Guell, Barcelona), Ferdinand Cheval (Palais Idéal, Hauterives, France), Simon Rodia (Watts Towers, Watts, California), Fred Smith (Concrete Park, Phillips, Wisconsin), Howard Finster (Paradise Garden, Summerville, Georgia), and Fr. Mathias Wenerus (Dickeyville Grotto, Dickeyville, Wisconsin). Other artists who stimulate her creativity are Alfonso Ossorio and the West Coast ceramic artists of the sixties—Robert Arneson, Roy De Forest, and Viola Frey. "My childhood role model, however, was my great-aunt Trude," says Onofrio. "She was a lovable, albeit eccentric folk artist who always worked outside the dictates of mainstream art."[77]

Onofrio's home and adjoining property (which she named Judyland) is a virtual museum of artifacts that showcase her life as an artist—a venture that began with ceramics in the late 1960s.

Onofrio abandoned clay in the early 1980s in favor of wood—a material more appropriate for making the understructure of large-scale sculptures. Where greater strength is required, she uses iron. It is upon such a foundation she attaches her miscellaneous materials in mosaic-like fashion. Onofrio's sculptures, fashioned in a baroquelike style, are well engineered and present a satisfying balance of form and surface ornamentation.

Among the qualities that make Onofrio's assemblages unique and so appealing are the spirit of play, naïveté, and whimsicality. Yet, beyond the amusing shapes, glitzy color, and surface ornamentation, her sculptures are narratives that tell of duality, temptation, seduction, and grandiose desires.

Judy Onofrio was born in 1939 in New London, Connecticut. She lives in Rochester, Minnesota.

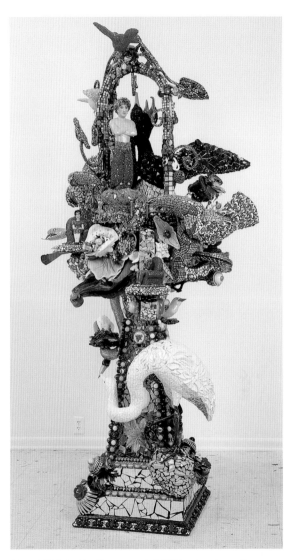

Fresh Catch, 2000, mixed media, 45 x 27^1/$_2$ x 12^1/$_2$",
courtesy of the artist.

Your Wish Is My Command, 1997, mixed media,
96 x 43 x 36", courtesy of the artist.

OPPOSITE: *Carrot Trick,* 1999, mixed media, 54 x 25 x 16", courtesy of the artist.

The Well-Humored Put-Down

And, after all, what is a lie? 'Tis but the truth in masquerade.

— LORD BYRON, POET

With an obsession for self-caricature and slapstick comedy, Charles Parness has been a clown prince of art for over thirty years. "Parness is a master of what might be called populist expressionism," writes critic Donald Kuspit. "His expressionistic art has an abstract sensibility, but exists in the service of humanity at large, as well as for the service of the artist's ego."[78]

Self-portraiture has been prevalent throughout art history; artists from the time of Vincent Van Gogh and Alexey von Jawlensky to postmodernists such as Robert Arneson, Joan Brown, and Robert Beauchamp have selected self-portraiture as a form of self-examination and as a means of conveying forceful emotions. Self-portraits lure viewers by a psychological attraction, as if they are mirrors, reflecting the countenance of the empathetic person who peers into them. Through the expressive correspondence and use of color, form, brushwork, and imagery, passion and feelings that span the entire range of human emotion can be portrayed in graphic form. Novelist and playwright Romulus Linney speaks perceptively of Parness's art: "What it does to me is make me smile, a little sadly, at the effort I must make to live his way: in good humor, in tolerance, and in understanding. What his work says, is that wisdom is delight, and deliverance is laughter."[79]

Indeed. Parness's caricatures are drawn from a personal life and philosophy; they succeed because they are cloaked in humor and situational waggery; furthermore, they are unpretentious, and evoke metaphors that have universal appeal. There are, of course, some images that are more personal and cryptic than others, akin to the "in-jokes," that require a specific frame of reference to be fully understood. Even here, however, the mind of the free-associating viewer has no problem in extracting sense from the artist's nonsense.

"Humor has always been central in my life," explains Parness. "The great comedians have been an inspiration. My enthrallment with the comedy of Jerry Lewis, the Three Stooges, Laurel and Hardy, Charlie Chaplain, and the Marx Brothers, and their zany sight gags, seem to epitomize my boyhood. Now, as an explorer of my psyche, I realize that I need to tap into my childhood in order to fully grasp my emotional experiences as an adult. The overly serious nature of self-portraiture in art history, in my mind, necessitated a change, a comic response."[80]

His amusing *Buck Fever* (1996), depicts six replicas of himself engaged in one of man's persistent obsessions, the quest for the almighty dollar. In comic

CHARLES PARNESS

PROFILE 29

96

fashion, he gives new meaning to the phrase "money makes the world go around." The comparison of game hunting to stock market investment does not go unnoticed in this representation.

In *Attila and the Rototiller* (1992), Parness appears to address the question of runaway (forgive the pun) technology, and whether humans are really smart enough to control the technology we are creating.

Parness believes that a penchant for absurdity is a mark of living well; as his friend Romulus Linney puts it, "To relish absurdities is to escape life's greatest danger, the delusion that we know what we are, who we are, what we are doing on this earth, and how to celebrate ourselves. We don't. It is folly."[81]

Charles Parness was born in Staten Island, New York, in 1945. He lives and works in New York City and in Vermont.

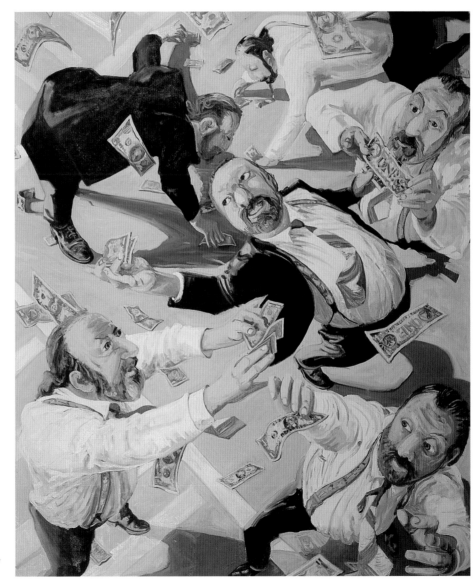

Buck Fever, 1996, oil on canvas, 60 x 78", courtesy of the artist.

Rub a Dub Dub, 1993, oil on canvas, 60 x 80",
courtesy of the artist.

Attila and the Rototiller, 1992,
oil on canvas, 60 x 78", courtesy
of the artist.

Archetypes and the Ordinary Man

For nearly four decades, Ed Paschke has dazzled viewers with extravagant imagery that has ranged from raunchy caricature to expressions of psychic and spiritual intensity.

Paschke's early works echo the motto of Moses Soyer, the American painter of social realism of the mid-1930s who once said to his students: "You must paint America, but paint with your eyes open; do not glorify Main Street. Paint it as it is—mean, dirty, avaricious."

Paschke's paintings of the 1960s fit Soyer's maxim to a T—they present the underside of American culture and are filled with raunchy images of strippers, pop stars, drag queens, cross-dressers, tattooed and beefy wrestlers, and a miscellany of other human misfits and eccentrics from the fringes of society.

"My early paintings were characterized by an attitude of confrontation," admits Paschke. "My work ethos was based on the theory that good art provokes and challenges viewers to evaluate their beliefs, otherwise it's just visual muzak."[82]

Paschke graduated from the School of the Art Institute of Chicago (SAIC) in 1961. After viewing the first exhibition by The Hairy Who in 1966, he assembled his own group of SAIC alumni two years later and exhibited as The Nonplussed Some. Although his art is associated with the Chicago imagists, Paschke's subject matter and photo-realistic style always set him apart.

In the late 1970s, his visual expression shifted to semiabstract figuration and caricatured figures with an offbeat, somber quality. Here, anonymous figures with masklike faces populate the canvases, while odd spectral bands of color provide further mystery. His paintings of this period might be read as satires of a spiritually impoverished culture—a society stifled by the erosion of human identity. As Paschke's painting style evolved, his colors began to crackle and pop like high-voltage charges from an overloaded transformer. Critics aptly characterized his art as "electrified, just this side of neon."

ED PASCHKE

PROFILE 30

Red-Green Buddha (2000) is an example of Paschke's work that began in the 1990s, the beginning of a period when he shifted to making iconic images with hints of psychic substance. In this series, Paschke brings forth vestiges of cultural icons, belief systems, and auras that encircle the images.

Although the Buddha figure is a universally known icon, its gist in Paschke's interpretation is remarkably altered, and the image is made ambiguous. Yet the translation begs viewer interpretation. "The properties of physical things tend to persist when their contexts are changed," says Marvin Minsky, a pioneer of artificial intelligence and cognitive psychology, "but the significance of a thought, idea, or partial state of mind depends upon which other thoughts are active at the time and upon what eventually emerges from the conflicts and negotiations among one's agencies."[83]

Red-Green Buddha, 2000, oil on linen, 60 x 78", courtesy of the artist.

Paschke's recent paintings clearly transcend the notion that beauty is in the eye of the beholder, for they entreat both the senses and the mind to negotiate one's inborn and educated feelings and intellect.

Ed Paschke was born in 1939 in Chicago. He lives in Evanston, Illinois.

Duro-Verde, 1978, oil on linen, 48 x 96", courtesy of the artist.

Improv at the Easel

Art should always make us laugh a little and frighten us a little, but never bore us.

—JEAN DUBUFFET,
ARTIST,
CHIEF REPRESENTATIVE
OF ART BRUT

JIM PICCO

PROFILE 31

Jim Picco's amusing, intuitively generated paintings and collages recall an anecdote of a visit by Marcel Duchamp, the French-American painter and founder of dada, to an art school in America. As Duchamp approached an art student struggling with a canvas at his easel, so the story goes, the student turned to Duchamp and said, "Frankly, I don't know what the #@%&#!! I'm doing." Reportedly, Duchamp tapped the young man on the shoulder and replied, "Keep up the good work!" Duchamp's seemingly facetious retort is taken as an exhortation to keep the rational mind in abeyance while the unconscious explores and unearths its undifferentiated wonders.

Like dream works, Jim Picco's comically surreal images such as *Knock-Kneed Chauffeur* (1997) stem from unfettered associations of unconscious impulses. Picco's modus parallels the Taoist philosophy of *wu-wei,* the notion of letting things happen, of going with the flow of the free, intuitive wanderings of the creative unconscious.

Jung noted that as one concentrates upon a fantasy image, there is great difficulty in keeping it quiet; it gets restless, multiplies, and becomes pregnant.[84] He hypothesized that the active imagination has two stages: first, letting the unconscious rise, and second, coming to terms with it. The first stage involves a form of meditation where rational control is suspended and fantasy is given free reign to search below the threshold of consciousness. In the second stage, the conscious mind is allowed to come into play and to reflect, nurture, refine, and unify the undifferentiated intuitions. Jung's hypothesis is in accord with Duchamp's revised definition of surrealism, which proclaims that fantastic thought originates through both logical and illogical mental processes.

Jim Picco's paintings and assemblages are born of intuitive ingenuity and whimsical caricature, a combination that churns up absurd, hard-to-fathom images that nonetheless trigger emotional responses that spill over into perceptual reality.

"The interaction of my unconscious impulses and the interplay of art material put me on high alert for unforeseen occurrences that arise along the way," says Picco. "Curiously, many of the things I love or hate seem to end up in my compositions. I don't try to pre-visualize how my work will appear in its final form, and I resist the temptation to edit, judge, or admire the improvisational images as they emerge. It's only later, after I've foraged enough visual material from my subconscious, that I allow my consciousness to fine-tune and supply finishing touches."[85]

Jim Picco was born in 1954 in Calgary, Alberta. He lives in Panni, Italy.

OPPOSITE LEFT: *Ragazzo,* 2001, oil on canvas, 20 x 16", courtesy of the artist, photo by Giuseppe Roberto.

OPPOSITE RIGHT: *Knock-Kneed Chauffeur,* 1997, crayon on paper, 38 x 50", courtesy of the artist.

Exhausted Alien, 2003, oil on canvas, 27 x 31", courtesy of the artist, photo by Giuseppe Roberto.

Wagging the Tale

Gerald Purdy's penchant for creating visual nonsense appears to be exceeded only by his disdain for conventional ideology. He proclaims himself "Ol' Anarchy"— an artist cynical of homogenized, lockstep expression—and he is keenly aware of the art world's desperate need for an infusion of some serious nonsense into its stodgy backside.

Purdy is an art jester with three personae—clown, trickster, and fool—and he brings a unique brand of comic relief to the humor-hungry art world. As clown-jester, he amuses his audience with preposterous narratives conceived in the benign spirit of playfulness and burlesque. As trickster-jester, he entices viewers to laugh at comic irony—the tenuous balance between chaos and order, and the sacred and the profane.

As fool-jester, he acts as the modern-day version of the traditional court jester, the wise fool who presents seemingly absurd statements that have the potential of bursting into metaphoric profundities.

Ol' Anarchy is the modern-day equivalent of the inveterate court and domestic jester—the wise fool who serves up entertainment, advice, witticisms, nonsense, and foolishness that can, depending on one's point of view, be perceived as buffoonery, playful wit, cutting satire, or all of the above.

A distinction between absurdism and nonsense, says humorologist Wim Tigges, is that while absurdism discards all formal structures and signification, nonsense, although remaining a perplexity, does not discount meaning altogether. Tigges believes nonsense encourages the audience's insight to perceive every sense, every reality as having its reverse, and that the value of nonsense is in keeping contradictory polarities in balance.[86] Purdy's artful nonsense is played out in beautifully painted visual narratives that pivot on this delicate balance between illusion and reality, an ambiguous quality invariably present in Purdy's iconography.

Art is my marker for Daddy's debt to society. But how can they catch me if I'm always chasing rainbows? Clickety-clack, an echo and back. Look out! Here comes Ol' Anarchy agin!

— GERALD PURDY

GERALD PURDY

PROFILE 32

About *Windsong* (2000), Purdy says, "I've always been fascinated with people who ride merry-go-rounds because of the ultimate futility of the trip despite all of the illusionist pleasure trappings. Most of the fun seems to be about looking at the other riders. It seems like the perfect setting for unrequited love and love-hate situations.

"*Guyz 'n' Girlies* [1999]—now here's an interesting image. All of the girls are straightforward copies of Cranach's classic nudes; the male figure on the left is an accurate copy of Massaccio's Adam, and the male figure on the right is an accurate copy of an incidental figure from a Mantegna painting (both Italians, by the way). The women's ensembles are bits of girlie magazine costumes I lifted. Since there are no snakes or other biblical stuff, I threw in the jazz musicians for seasoning."[87]

Gerald Purdy was born in 1930 in Chicago. He lives in Hillsboro, Oregon.

OPPOSITE: *Guyz 'n' Girlies*, 1999, oil on panel, 16 x 28", courtesy of the artist.

Windsong, 2000, oil an panel, 15 x 20", courtesy of the artist.

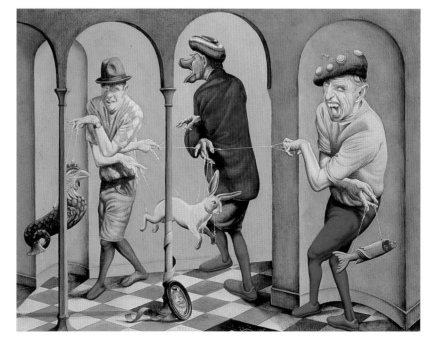

Walking the Dog, 1996, oil on panel, 16 x 20", courtesy of the artist.

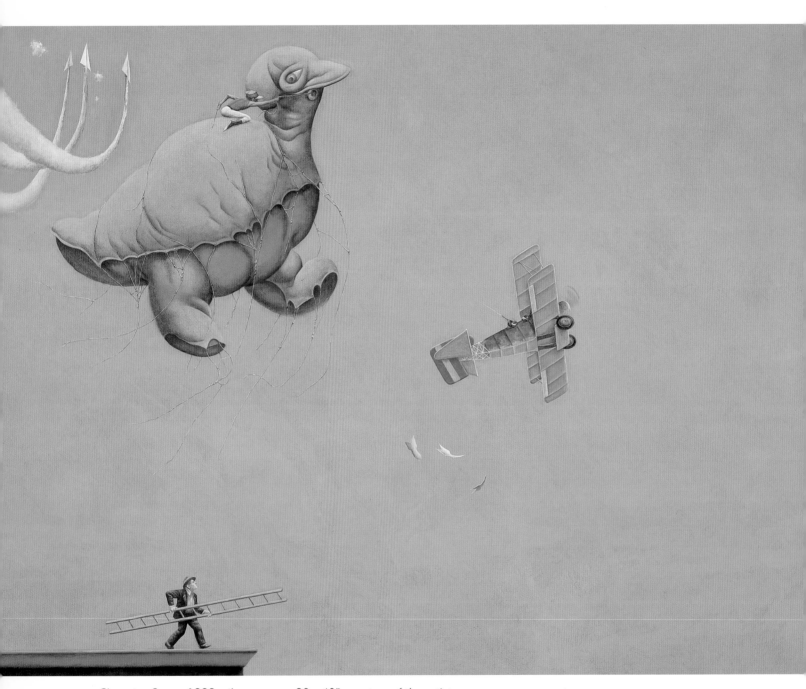

Changing Scene, 1999, oil on canvas, 30 x 40", courtesy of the artist.

Music for the Eyes

The closest analogy for Reginato's sculpture is jazz.

— PETER CLOTHIER,
ART CRITIC

There's nothing subtle about Peter Reginato's playful, hyperenergetic sculptures. Critics appropriately liken this New York City artist's art to jazz. "The shapes in his compositions don't just stand there frozen in space; they dance for us!" exclaims gallery director Warren Adelson.[88] Indeed, Reginato's playful choreography of line, shape, color, and form swings like syncopated musical riffs, and his work brings to mind Duke Ellington's exhortation to his band—"Gentlemen, make your phrases dance!"

Like jazz, Reginato's visual harmonies are forged by deliberate and improvisational phrasing and are guided by both intellect and emotion. Although his art is classified as sculpture, it appears more like a hybrid of painting and sculpture, or like painting that has morphed into sculpture.

His unique way of balancing visual elements in space reinstates Piet Mondrian's hypothesis that forms, forces, and counterforces in visual compositions must be controlled to attain a "felt balance," a state of dynamic equilibrium.[89] Reginato's eccentrically balanced constructions nod to both Mondrian's concept of dynamic balance and to Alexander Calder's spirit of playful creativity. And, from the emotional and spiritual perspective, Reginato's art is close to the philosophy of Wassily Kandinsky, the Russian painter and teacher, who equated visual composition to music. "The artist who is unsatisfied in mere surface representation naturally seeks the methods of music to express his soul," wrote Kandinsky.[90]

Reginato says humor is not something he intentionally seeks, but something he discovers while his work is in progress or after it is completed. "In the construction of *Your Mama* [2000–01], I thought the idea of putting a small sculpture inside the larger one was pretty funny, and at the same time it reminded me of Matisse's early painting *The Joy of Life*, a composition of many unrelated elements that are brought together as a whole, but at the same time question that wholeness."[91]

The casual observer might conclude that Reginato's constructions are tenuously balanced, but they are in fact well engineered with a stable center of gravity. The parts are solidly welded together. Interestingly, Reginato does not make preliminary sketches to pre-visualize his sculpture, preferring instead to improvise and work directly, adding the various constituent parts piece by piece, while balancing the sculpture "from the ground up, until I reach the top."[92] The procedure is not unlike the performance of a carnival juggler who twirls and balances plates and

PREVIOUS PAGE: *Another Weak Moment,* 2001, steel painted with Insl-Tron, 40 x 18 x 10", collection of Jan and Warren Adelson.

saucers on the ends of sticks, adding plates as he goes, and somehow managing to keep everything spinning and airborne with gravity-defying skill.

Reginato's sculpture is abuzz with movement, yet it has no motorized or moving parts. Although static, his sculpture oscillates by virtual kineticism, an effect created by the peculiarity of human optical perception wherein the eye intuitively jumps throughout the myriad of focal points within a given optical field and generates perceptual linkages and rhythms. The kinetic effect is further activated by the viewer's movement, which produces different visual alignments as he or she moves around the work.

Symbolically, Reginato's art is emblematic of contemporary urban life; it is lively, colorful, and raucous. Color is assigned to shapes with thoughtful deliberation. "To me, each shape is individual and should have a different color," says Reginato. "Shapes have personalities, painting them not only helps free up the structure, but also allows me to express my feelings more fully."[93]

Peter Reginato was born in 1945 in Dallas, Texas. He lives in New York City.

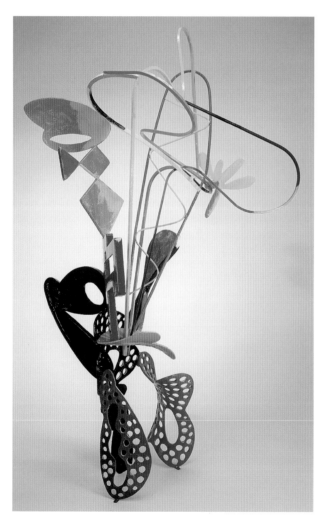

Bottom of the Half, 1993, steel painted with Insl-Tron, 73 x 49 x 38", collection of Mike and Tania Sunberg.

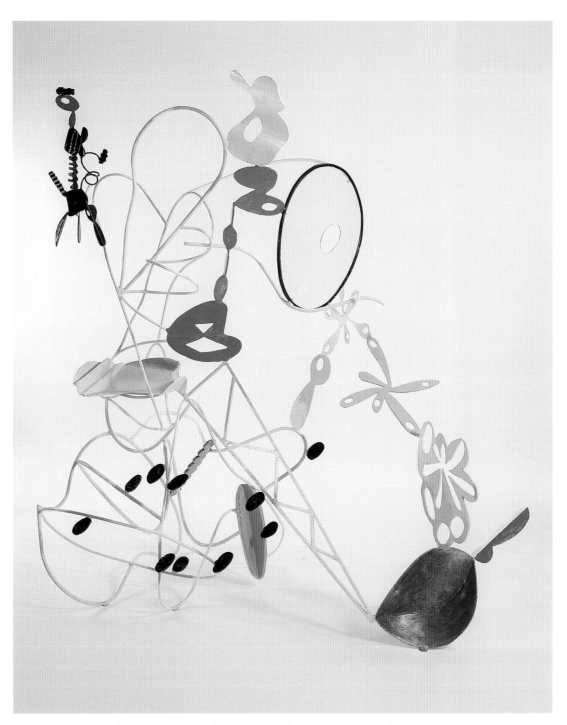

Your Mama, 2000–01, steel painted with Insl-Tron, 73 x 69 x 40", collection of the artist.

Teapots and Bon Mots

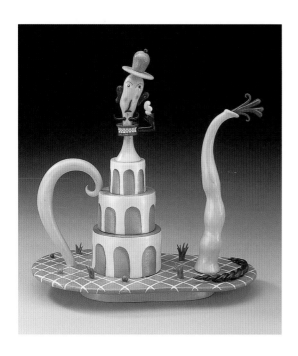

I can believe anything,
as long as it's incredible.

— OSCAR WILDE,
WRITER

TOM RIPPON

PROFILE 34

Tom Rippon's whimsical teapot tableaus are funny on their own, but they are also funny for the clever potshots (forgive the pun) they fire at fine art orthodoxy and its long-held condescension of ceramic art.

Rippon's porcelain teapots are irrational and extravagant, precariously balanced, delicate, elegant, and witty, but they are definitely not for serving tea. They are teapots to make you laugh, and they invite you to celebrate the ceramic artist's newfound freedom.

Rippon's passion for ceramic sculpture was inspired by his aunt, Ruth Rippon, a pioneering ceramic artist and teacher from Sacramento, California, and by his mentor Robert Arneson at the University of California, Davis, in the 1970s. From his informal association with Arneson, Rippon learned to appreciate the vast potential of clay as a medium for visual expression, once liberated from its traditional utilitarian function. Arneson also encouraged him to paraphrase historical references as a methodology for art (for example, *Self-Portrait as an Italian Architect*, 1998), a system Rippon continues to employ.

Rippon attended the Art Institute of Chicago from 1977 to 1979, where he obtained a master's degree and came in contact with the work of the Chicago imagists. Like the imagists, he became fascinated by the art of self-taught outsiders, folk artists, the comics, and popular culture—elements of which are invariably reflected in his work.

As Rippon's art matured technically and conceptually, his experiments led him to develop an unconventional technique with clay that facilitated the production of art with a highly finished surface. His method centers on carving, sawing, sanding, and smoothing dry clay and then coating the unglazed porcelain elements with low-fire overglazes to create silky tones of color. Finally, the various parts are assembled on hidden metal rods, glued together with epoxy, and mounted on a platform base.

The openness and rich color of Rippon's constructions recall Alexander Archipenko's (1914) plea for a new class of sculpture, "a polychromed art that unifies form with color, is adjustable according to symbolic or stylistic predilection,

and points away from the sculpture of solid form toward a sculpture of space, color, and light."[94]

Rippon's three-dimensional art is created in agreement with Archipenko's advocacy, but it is also identified by its liberal helping of whimsicality. The revisioned teapot exemplifies Rippon's signature style and distinguishes him as an original thinker among the innovative breed of contemporary American ceramic artists who have helped rid the art establishment's antipathy toward humor and ceramic art. But the teapot is but one example of art that issues from Rippon's fertile imagination. *Proper Shoppers* (2002; see page xiii), a whimsical parody on the urban consumer, and *Domestic Icon* (1988), a comically surreal amalgamation of figurative and industrial elements, further demonstrate Rippon's mirthful versatility.

Tom Rippon was born in 1954 in Sacramento, California. He lives in Montana and teaches at the University of Montana, Missoula.

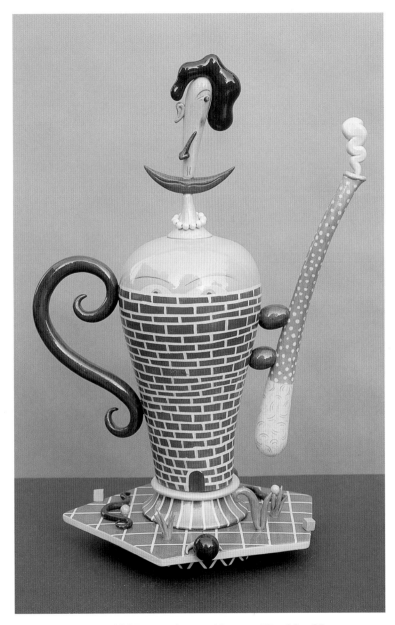

OPPOSITE: *Self-Portrait as an Italian Architect,* 1998, lusters, acrylic, pencil, and porcelain, 14 x 7½ x 14", courtesy of the artist.

Cafetière l'Amour, 1997, porcelain and lusters, 19 x 12 x 9", courtesy of the artist.

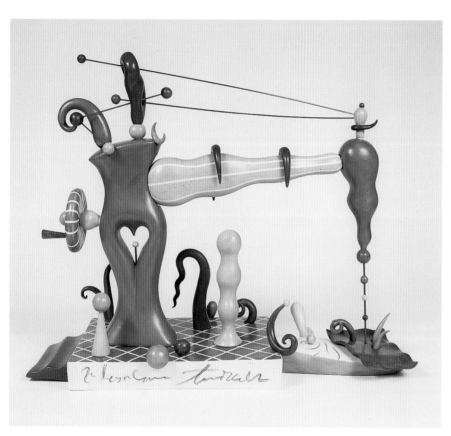

Domestic Icon, 1988, clay and glazes, 14 x 16 x 12", courtesy of the artist.

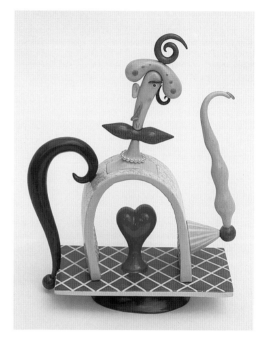

A Questionable Pose, 1998, porcelain and lusters, 14 x 10 x 6", courtesy of the artist.

Tapping the Springs of Instinct

Out of this confusion the mind will be furnished with an abundance of designs and subjects, perfectly new.

— LEONARDO DA VINCI,
ARTIST, ARCHITECT,
ENGINEER

ANN ROGULA

PROFILE 35

Ann Rogula's densely packed and brightly colored paintings begin as automatic line drawings—a kind of absentminded doodling not unlike those anyone might unconsciously make while engrossed in phone conversation. Her method of starting is to cover a sheet of paper, corner to corner, with random scribbles, producing an overall maze that in turn serves as a procreative stimulus for her paintings.

The use of unorthodox and chance methods to stimulate the creative imagination is not new. When Leonardo da Vinci encouraged his students to examine the stains and eroded surfaces on weathered walls over five hundred years ago, his intention was to prompt them to discover designs from unlikely sources. "Although trifling in appearance, it may yet be of considerable service in opening the mind and putting it upon the scent of new thoughts," asserted Leonardo.[95]

Chance methods were also integral to dadaist and surrealist artists of the 1900s, who employed a system they dubbed "surrational automatism"—a technique of allowing one form to give rise to another by intuitive means until a "felt unity" was achieved.

Rogula says that almost from the first moment that she begins to contemplate her procreative scribbles, she discovers faces, figures, and shapes that begin to pop up everywhere. "The images originate from my subconscious. Characters emerge, and their personalities project different emotions and characteristics. They interact with each other just as real people do; they gesture and articulate, reveal different expressions, and are involved in a sort of nonverbal communication that parallels human conversation."[96]

From the infrastructure of doodles, Rogula extracts a profusion of cartoonlike characters that fill her canvases and become protagonists and supporting actors in odd and enchanting dramas.

"I find humor in the characters, but for me it's the kind of humor that comes from recognizing parts of yourself in someone else, and sort of laughing at yourself. *Prince Charming* [1997] is a painting that describes a state of balance—of waiting and watching—and of circular motion. The characters form a tight-knit group. All share parts of their makeup with two or more of the others. They are complete as individuals, but at the same time require the presence of the others to remain complete."[97]

In *Offering* (1997) Rogula presents an autonomous character dancing in place while offering her heart. The image is an expression of personal emotion

reminiscent of certain religious images of Hindu and Christian paintings where a deity is similarly portrayed.

Because the figures and shapes in Rogula's compositions tend to be inter-locked, the subject-ground relationship of her designs appears ambiguous. Her use of color also affects the picture plane by allowing certain brightly painted figures to optically "pop up," while those of muted tones recede.

Still, even with the ambiguity, fantasy, and comic figuration that freely inter-mingle in Rogula's paintings, her conceptions furnish joyful recollections and psychological impressions about people and issues in the real world. "I see my characters with love and humor, and I hope that viewers will recognize aspects of themselves and of people they know in these playlets."[98]

Ann Rogula was born in 1964 in New York City. She lives in Chicago.

A

B

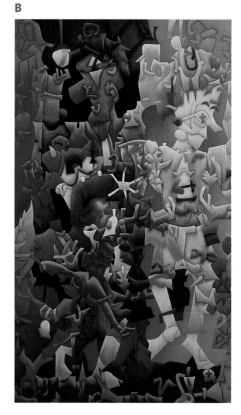

A Automatic line drawing for *Offering,* 1997, ink on paper, 13 x 19", courtesy of the artist and Jean Albano Gallery, Chicago.

B *Offering,* 1997, oil on canvas, 50 x 30", courtesy of the artist and Jean Albano Gallery, Chicago.

Sojurn, 1999, oil on canvas, 32 x 38", courtesy of the artist and Jean Albano Gallery, Chicago.

Teasing the Imagination

*Passions are generally
roused from great conflict.*

—TITUS LIVIUS,
HISTORIAN

ALLAN
ROSENBAUM

PROFILE 36

Allan Rosenbaum's studio is a place where the familiar intersects with the fantastic, where everyday images are transformed into strange and provocative objects.

"I use the human figure in my art because it offers a great opportunity for narration and metaphor making," says Rosenbaum. "Aside from the challenge of modeling a fair likeness of the human figure, there's also the enticement to update the classical mode of figuration established by art history."[99]

In the latter regard, Rosenbaum seeks to extend the tradition of objective representation to that of passionate, abstract representation, in which various emotions, fantasies, and realities can intersect. He accomplishes this by creating caricatured figures that are subsequently transformed (and subjectified) with techniques such as cropping, shifting scale, reorienting elements in odd ways, rearranging body parts, combining organic and inorganic elements, and hybridizing—fusing one subject with another. Such procedures, of course, tend to make images appear conflicted, ambivalent, amusing, and surreal—exactly what Rosenbaum needs for constructing comic metaphors.

Rosenbaum's *Toaster* (2000) paraphrases Robert Arneson's earlier work, created in 1965, in which Arneson made a toaster with fingers reaching out from the bread slots. By revisioning Arneson's work, Rosenbaum honors his legacy as a pioneer of visual humor in contemporary art and gets extra mileage from the image by turning the toaster into a push toy.

Wheelbarrow (1997) is a visual non sequitur that musters psychological tension; its dreamlike imagery is fraught with latent symbolism. From one perspective, the grotesque *Wheelbarrow* might be read as a commentary on mass media's overwhelming output of images and information. "We need a wheelbarrow," says Rosenbaum, "how else can we carry around all the stuff that's being crammed into our heads!"[100]

Waterfall (1998) is a hybridized image made from the marriage of incompatible objects. Here, a truncated human torso has a head made of books, topped with a small house from which a waterfall spouts. A prosaic interpretation would be to read the image as a symbol of man's enrichment through academic education, the

house being the self, specifically the mind, wizened by pedagogy and book learning. Water might be interpreted as enlightenment flowing from the mind. Of course, being ambiguous, the image stimulates innumerable interpretations, any of which may be viable to the viewer.

In sum, Rosenbaum's perplexing works are traps for the imagination; they are ingeniously constructed poetic climates designed to simultaneously address conflicting thoughts and emotions and to challenge viewers to look at the world in a different way. The fun of trying to extract meaning from non sequiturs pivots on the procreative energy generated by the clash of incompatibles—an energy that can readily ignite the free-associating mind. Clearly, this is an art for contrarians, for those who love to have their imaginations teased.

Allan Rosenbaum was born in 1955 in St. Louis. He lives in Richmond, Virginia, and is associate professor at Virginia Commonwealth University, Richmond.

OPPOSITE: *Toaster,* 2000, earthenware, stain, and glaze, 23 x 16 x 12", collection of Maura and Gene Kistler, photo by Katherine Wetzel.

Wheelbarrow, 1997, earthenware, stain, and glaze, 13 x 19 x 13", collection of Drs. Matthew and Cynthia Galumbecks, photo by Katherine Wetzel.

A

B

A *Thinking Chair,* 1998, earthenware, stain, and
 glaze, 18 x 19 x 14", collection of Diane and
 Marc Grainor, photo by Katherine Wetzel.

B *Waterfall,* 1998, earthenware, stain, and glaze,
 23 x 24 x 12", courtesy of the artist, photo by
 Katherine Wetzel.

It's All in How You View It

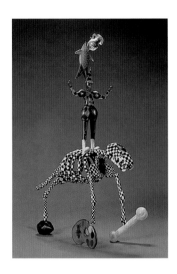

Those in the world who have the courage to try and solve in their own lives new problems of life are the ones who raise society to greatness.

— SIR RABINDRANATH TAGORE, POET

GINNY RUFFNER

PROFILE 37

Ginny Ruffner's joyful and beautifully crafted glass sculptures rank among the finest in America. Her stunning lampwork creations are coveted by collectors and museums worldwide as testaments to her formidable technical and conceptual skills, as well as to the extraordinary potential of glass as a fine art medium.

Lampworking (also known as flame working) is based on the art of heating and shaping glass rods over a torch flame. Ruffner's method of lampworking is unique. By sandblasting annealed glass (glass that has been heated, then cooled to be made less brittle), she prepares etched surfaces to make them receptive for drawing and painting, thus opening up endless possibilities for surface embellishment.

After graduating in 1975 from the University of Georgia with a degree in painting and drawing, Ruffner learned the craft of lampworking from Hans-Godo Fräbel, a German immigrant who had set up a glass studio and gallery in Atlanta. After five years of training, she set off on her own to explore the possibilities of lampworked glass as a fine art medium. In 1986, inspired by Marcel Duchamp's large glass construction *The Bride Stripped Bare by Her Bachelors, Even* (1915–23), she began to combine her talents as a painter and glassworker. Duchamp's visual punnery and wordplay further stimulated Ruffner to incorporate humor in her polychromed glasswork.

The year 1991 was a fateful one for Ruffner. She was president of the Glass Art Society and served on the Seattle Art Commission and on the board of the Pilchuck Glass School. She had solo shows in prime galleries and art museums in America and abroad. But in December 1991, she suffered a traumatic car crash that changed her life. The accident left her comatose for five months, and doctors offered little hope for her survival. When she awoke from the coma, her identity had been erased and her body was badly disabled. She had a difficult road ahead of her, a long period of rehabilitation during which she had to relearn everything about herself and her art. Miraculously she returned to her art studio only seven months after the horrific accident that nearly ended her life.

Now, aided by a devoted art team in her Seattle-based studio, she has resumed her career as a glass artist. Themes such as the Balance series reflect on the rigorous rehabilitation programs she undergoes to restore physical balance and coordination. "When I started the Balance Series, it was about regaining my own physical sense of balance, but the concept expanded to other areas that need balance, too, like life and art—and relationships."[101]

A sharp wit and sense of humor, along with exuberant creativity, exude from her creations. The writer Romain Gary once commented that humor is an affirmation of dignity and a declaration of our superiority to all that may befall us. Gary's words are particularly poignant given the circumstance of Ruffner's tragic accident and her determined effort to overcome the handicaps it imposed.

Ginny Ruffner was born in 1952 in Atlanta, Georgia. She lives in Seattle, Washington.

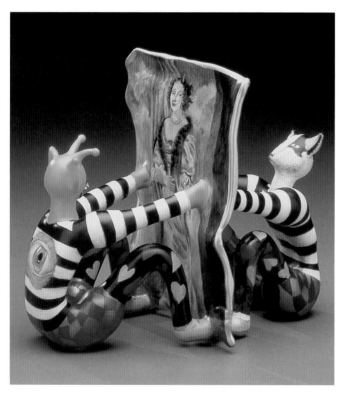

The Power of the Mind (Balance series), 1995, lampworked glass and mixed media, 7 x 9 x 6", courtesy of the artist, photo by Mike Seidl.

It's All in How You View It, 1994, lampworked glass and mixed media, 15 x 7$\frac{1}{2}$ x 7$\frac{1}{2}$", courtesy of the artist, photo by Mike Seidl.

Well-Tempered Trash

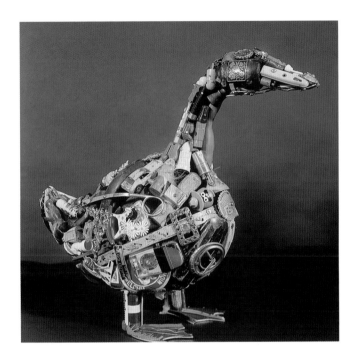

LEO SEWELL

PROFILE 38

As fate would have it, Leo Sewell's parental home was located near a United States naval dump—a proverbial gold mine for an aspiring assemblage artist. The great heaps of scrapped objects that he saw at the junkyard were as beautiful to young Sewell as the mountains of rubbish in the French junkyard were to Van Gogh a hundred years earlier. However, unlike Van Gogh, who was fascinated by the aesthetic beauty of the dump site yet entertained no desire to fabricate anything from its contents, Sewell hauled castoffs from the naval junkyard to his studio, where he cobbled junk into fine art.

Sewell has been "pickin' trash" and making art for almost thirty-five years, and because many of his art subjects are prehistoric animals, he has been dubbed "the artist from Philly who turns contemporary junk into extinct art."[102] Viewed from across the room in a gallery setting, his animal sculptures appear to have a fairly normal configuration, but up close they reveal astounding surface ornamentation—conglomerations of carefully arranged watches, costume jewelry, sunglasses, and hundreds of miscellaneous objects from popular culture that are ingeniously assembled to form the likenesses of horses, ducks, penguins, and other animalia.

Sewell's passion for making art crammed to the gills with junk gives new meaning to the term *horror vacui*, the fear of empty space. "I figure the worst thing for the eye to contemplate is plainness," says Sewell, "so I fill my works with lots of stuff for the eye to feast on."[103]

His sculptures begin as line drawings on paper in which a subject's different views—side, front, and overhead—are displayed. Subsequent drawings are made to visualize how the subject's surface might appear with an ornamentation of junk objects. With the image fairly well established in his mind, Sewell begins the structural work. His first step is to search for a suitable core, which is usually a wooden object that serves as the inner armature to which he attaches the myriad found objects.

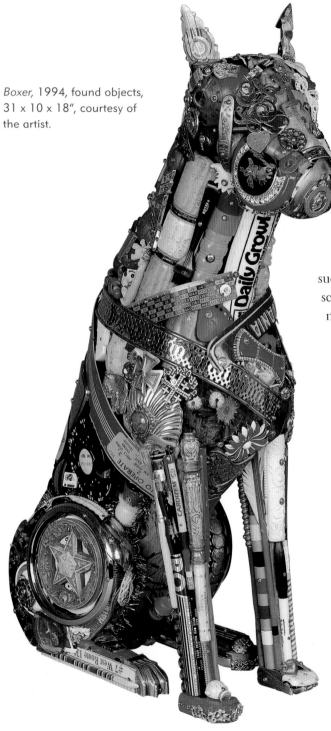

Boxer, 1994, found objects, 31 x 10 x 18", courtesy of the artist.

Sewell says, "If I were to make a three-foot-high sculpture of an imperial penguin, for example, the core would probably be made from part of a rafter from a Victorian house, or perhaps part of a couch or bureau. On the sides of that I'd screw handles of hockey sticks for the legs. I might take the arm of a chair and screw that onto the core for the neck and head, and the beak would be attached to that. The feet would be cut out of flat metallic sheet such as discarded signs. Then I'd build up the bulk of the sculpture with a variety of found objects, and as I get near the final surface, I'd apply more plastic and metallic objects like watches, kitchen utensils, etc."[104]

Why do people laugh at Sewell's sculptures? Probably because they love surprise, and Sewell's art is chockablock with surprises. Children love Sewell's sculptures because they laugh at anomaly. Laughter signals the discovery of an incongruity and the pleasure it provides while it is accepted and integrated into their world of knowledge and to their expanded universe. Sewell's art, incongruous as it may be, is a reminder that the last laugh is on us, because that laugh just might signify a major reconstruction of our heretofore held notion of what art is "supposed" to be.

Leo Sewell was born in 1945 in Annapolis, Maryland. He lives in Philadelphia, Pennsylvania.

PREVIOUS PAGE: *Duck,* 1993, found objects, 16 x 8 x 16", courtesy of the artist.

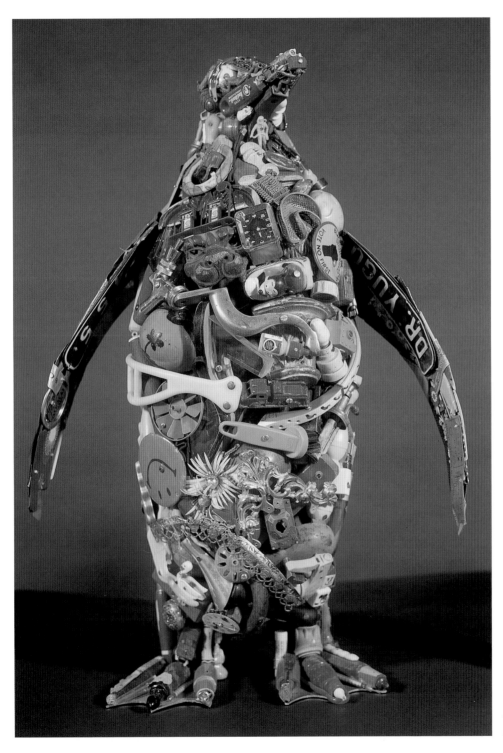

Imperial Penguin, 1981,
found objects, 32 x 16 x 13",
courtesy of the artist.

Eye Trickster

Visual reality: It isn't what you think it is.

—ANON

Richard Shaw is a remarkably ingenious surrealist and master of visual illusion. "I can't believe this is made of clay!" is a commonly heard exclamation from astonished viewers at exhibitions of his trompe l'oeil sculpture.

With loving attention for minutia, Shaw replicates objects of all kinds—playing cards, tin cans, pencils, shoes, gloves, twigs, hats, foodstuffs—and transforms them into extraordinarily believable objects. The *House of Art Tumbles* (1996) and *House of Pencils on Artist's Box* (1999) are typical examples of Shaw's artful deception. His art is funny because it's made by an honest liar—it's fun to be fooled! His artful deception neatly divides illusion from reality; it pivots on a zany brand of irony, witwork, and craft skills that border on wizardry.

The art of trompe l'oeil is said to have originated in Greece in the fifth century. Pliny the Elder described a painting competition in which Parrhasius competes with Zeuxis. According to legend, Zeuxis produced a painting of grapes so lifelike that birds flew up to it. Parrhasius, to meet the challenge, presented a painting of a curtain. Zeuxis, thinking he had won the trompe l'oeil competition, asked Parrhasius to draw the curtain to reveal his painting. When he realized his error, he immediately yielded the prize, declaring that whereas he himself had deceived the birds, his opponent had tricked the trained eye of an artist.

For many art lovers, the meaning of trompe l'oeil is synonymous with the famous painting *The Old Violin*, by nineteenth-century American artist William Harnett, or with more recent art by American photo-realists such as Don Eddy and Ralph Goings. Unlike the art of photo-realists, however, Shaw's figuration leans toward the surreal and is closer in spirit to Arcimboldo, the iconoclastic Milanese artist who painted faces comprised of a medley of disparate objects.

Witty eccentricity notwithstanding, there lurks in his work an inkling of social commentary. As an example, there is the recurring theme of "the striding figure"—an image rich with symbolic potential. One perspective suggests that the image is a metaphor of art, striding toward its ultimate destiny; another suggests it is the artist himself, in search of revelation.

Shaw's art evolves from a variety of labor-intensive technical procedures. He begins by making plaster molds of objects selected for slip casting. The castings are kiln fired, then decorated with ceramic decals with textures and images that simulate the surface of the original object. The ornamented elements are fired a second time, and the constituent parts are then glued together with epoxy.

Although his anthropomorphic figures are comprised of familiar elements, the various parts are eccentrically combined and evoke surreal representations; paint cans become heads and torsos, twigs are turned into arms and legs, a neck is made of stacked hamburgers, a bowler hat becomes a pelvis, and tubes of paint become fingers.

The optical trickery is facilitated by the unique ceramic decal technique Shaw and his friend Wilson Burrows devised in 1974: images and textures are screened onto special paper followed with a coating of enamel. Placing the screened prints in water softens the paper backing so the decals can be released and transferred to selected bisque-fired surfaces. The final firing burns away the enamel, leaving the images permanently in place on the sculpture's surface.

"I like illusion, whether two-dimensional or in the round," says Shaw. "Limiting myself to a particular material like porcelain and making something out of it that looks like another material has a magic that I like."[105]

Richard Shaw was born in 1941 in Hollywood, California. He lives in Fairfax, California.

PREVIOUS PAGE: *Striding,* 2000, glazed porcelain with decal overglaze, 37$^{1}/_{2}$ 10 x 19$^{1}/_{2}$", Braunstein-Quay Gallery, San Francisco.

House of Pencils on Artist's Box, 1999, porcelain with decal overglaze, 8 x 18 x 10", Braunstein-Quay Gallery, San Francisco.

A

B

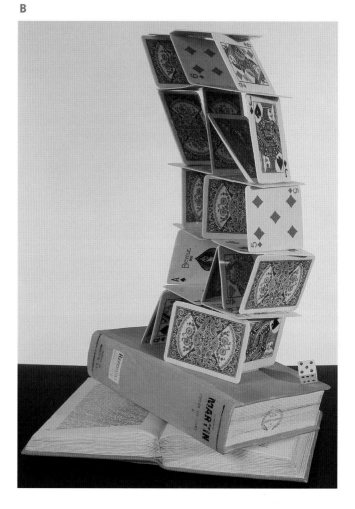

A *Little French Girl,* 1996, porcelain with decal overglaze, 61 x 17¹/₄ x 12", collection of the San Jose Museum of Art, San Jose, California.

B *House of Art Tumbles,* 1996, porcelain with decal overglaze, 17 x 12 x 10", Braunstein-Quay Gallery, San Francisco.

Last Judgment Dancer

Printmaker Mick Sheldon has devilish good fun skewering self-deceiving hypocrites who blithely swing between acts of temptation and virtue. He draws laughter in a way the prudish would consider irreverent—by intermixing theologic subject matter with slapstick comedy. "Why do I enjoy making visual satires? Because I want to make people laugh uncomfortably," says Sheldon. "But when the laughing is done, I hope there is something more."[106]

Sheldon's version of *The Battle Between Carnival and Lent* (1992) addresses the same issues that Bruegel preached over four hundred years ago in his classic painting of the same name—a theme that pokes at hypocrisy and self-righteousness. Bruegel's painting *The Battle Between Carnival and Lent* (1559) is an extravaganza of revelry and excessive behavior that satirizes the three-day festival of frantic eating, drinking, and carousing that precedes the forty days of Lent.

In his updated version of *Carnival,* Sheldon caricatures himself (as a robed figure) placed squarely in the center of both panels of the diptych. He pictures himself as a reveler tempted by the devil in one panel and as a contrite, prayerful sinner in the other. "It's a metaphor of the times," says Sheldon. "The people who are carousing during carnival are the same ones who tomorrow will be repenting throughout Lent."[107]

Sheldon's graphic style evolves from studying history, scripture, and mythology and from examining works by Albrecht Dürer, Emil Nolde, Katsushika Hokusai, Ando Hiroshige, and the German expressionist woodcut artists. His creative expression is also tempered by the saucy style of the West Coast underground comic book artists of the 1960s.

Sheldon's printmaking process is as bizarre as his subject matter. "I print my woodcuts (which I carve on birch plywood) on white rag paper by driving over them with my Ford van," he explains. "Several runs over the prepared blocks are usually required before I get the print quality I'm looking for. Sometimes, though, I don't use the car; instead, I dance on the inked plates. The Mashed Potato seems to work best."[108]

MICK SHELDON

PROFILE 40

PREVIOUS PAGE: *The Battle Between Carnival and Lent,* 1992, watercolor on woodblock print, 30 x 44", courtesy of the artist.

Some say Mick Sheldon is a moralist posing as a libertine. That is for each viewer to determine. Clearly, Sheldon has an amusing and compelling way of presenting ageless allegories recast in the present. Because they are fictions grounded in comic book vernacular, they appear funny at first glance, but the wary viewer doesn't take long to realize that Sheldon's humor is caustic satire that speaks of human frailty, perversity, and violence. All of which seems to reinforce the old adage: "The more things change, the more they remain the same."

Mick Sheldon was born in 1951 in Reno, Nevada. He lives in Yolo, California.

Last Judgment Dancer: Miss Spiral Nose-Cone Twirls Burning Batons, 1999, watercolor on woodblock print, 36 x 24", courtesy of the artist and Solomon-Dubnick Gallery, Sacramento, California.

Slingshot toward Heaven, 1999, watercolor on woodblock print, 48 x 36", courtesy of the artist and Solomon-Dubnick Gallery, Sacramento, California.

Tooning in to Reality

Shimomura's irony and humor help to move the viewer beyond visual and psychological barriers into a more promising space where cultures cross and we are all the richer for it.

— JACQUELYN DAYS SERWER, CHIEF CURATOR, CORCORAN GALLERY, WASHINGTON, D.C.

ROGER SHIMOMURA

PROFILE 41

Although Roger Shimomura's visual expressions center largely on issues of ethnicity from the perspective of the Japanese-American experience, his art clearly speaks to a universal audience with concern for the enhancement of global harmony and human equity. Shimomura's art is humorous to the degree that it is made of funny cartoon images set in perplexing contexts and juxtapositions. But at its heart, it is humor cast of bittersweet satire.

Shimomura was born in the United States as a Sansei, a third-generation person of Japanese heritage. As a three-year-old, he was one of 117,000 Japanese living in the United States in 1942 when president Roosevelt signed the order to intern persons of Japanese heritage, a direct response to the bombing of Pearl Harbor.

Shimomura's *Diary: December 12, 1941* (1980) is a painting inspired by his grandmother's journal entry, written five days after the bombing of Pearl Harbor while in an internment camp. With sardonic wit, he presents an image of a woman seated in a confined space, seemingly in a state of resignation, while the shadowy figure of Superman stands guard for America behind a shoji screen.

Shimomura's pictorializations are a curious blend of Eastern and Western motifs. Disney World characters and American comic book icons are loosely intermingled with samurai and geisha, and Western pop art is freely combined with images derived from Japanese ukiyo-e woodblock prints.

When asked why he uses the comics style, Shimomura replies, "It probably goes back to my childhood love of comic books, and to the realization that the Japanese ukiyo-e woodblock prints [which evolved from the sixteenth and seventeenth century style of genre paintings] are nothing more than a Japanese version of American comic books."[109]

Kabuki Play (1985) combines American pop images Donald Duck and Cinderella, a kimono-clad Japanese woman, a Kabuki player, and a Japanese dive bomber—all amalgamated in a pop-style painting reminiscent of Roy Lichtenstein's comic-strip-inspired compositions from the 1960s. Symbolically, Shimomura's painting nods to Pearl Harbor, yet its ambiguous iconography is open to speculation.

Enter the Rice Cooker (1994) might be construed as a metaphor of blossoming pluralistic culture in America. In this slice of multicultural reality, Shimomura allows the viewer to peek into the window of a North American home. Inside, one

sees a shoji screen and behind it, in silhouette, a Western woman's figure—a Betty Grable look-alike. A traditional Japanese male figure, carrying an electric rice cooker, is about to join her.

Comic book inspired imagery is becoming more visible in gallery exhibitions throughout the world. It appears that the merging of cultures, and the blurring of high and low art, has at last vaulted cartoon figuration into the pantheon of mainstream art. Its newfound legitimacy and status have to a certain degree been made possible by the persistent vanguard efforts of artists such as Shimomura.

Roger Shimomura was born in 1939 in Seattle, Washington. He lives in Lawrence, Kansas, and is professor of art at the University of Kansas.

Enter the Rice Cooker, 1994, serigraph, 36 x 41", courtesy of the artist.

Diary: December 12, 1941, 1980, acrylic on canvas, 50 x 60", courtesy of the artist.

Kabuki Play, 1985, lithograph, 21 x 21", courtesy of the artist.

Form Follows Fun(c)tion

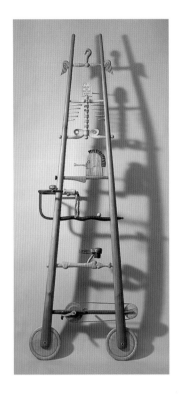

Surely the strange beauty of the world must some- where rest on pure joy!

—LOUISE BOGAN, POET

TOMMY SIMPSON

PROFILE 42

Although best known for his art furniture, Tommy Simpson's talent is also reflected in graphic art, painting, and sculpture—all of which bear his trademark wit and humor. "I don't actually set out to make humorous furniture or art," Simpson explains. "I'm just being me, making stuff, and it usually comes out in a humorous way because I just can't seem to avoid it. It happens unconsciously because that's the way the work seems to want to solve itself. I think the key words that describe my creative process are joy and playfulness."[110]

Simpson's art furniture—manifested in the form of clocks, cabinets, armoires, chests, tables, desks, chairs, panels, and beds—might best be described as a blend of fanciful creativity and impeccable craftsmanship that is tempered with a bizarre sense of humor.

"If you're playful with something, you are open for experimentation, and for new ideas to emerge," Simpson says. "So, in a sense, what you're doing is putting up a model for learning. On the other hand, if your work ethic is dogmatic or pre- scribed, then you're not learning anything new; you might become very facile at what you're doing, but chances are you won't be getting any new insights."[111]

His fine art expression nods to the surreal art of Miró, Calder, Picasso, and Klee, and to the idiosyncratic works of H. C. Westermann—artists who have con- sistently displayed a penchant for lighthearted whimsy in their art. Also of significant influence on Simpson's aesthetic are the design-rich works of Matisse and Kandinsky, the art of the Northwest Indians, folk art from the South Pacific and Africa, and early American arts and crafts.

Simpson is an artist who refuses to accept the notion that there might exist a dichotomy between functional and nonfunctional art, and to prove it, he produces objects that are both, insofar as they are at once furniture *and* art. Which ulti- mately begs the simple question, *Why* art furniture?

Perhaps Peter Joseph, former director of a prestigious New York art furniture gallery answers the question best when he says, "A home filled with furniture is a portrait in collage that we make of and for ourselves. We define ourselves through our furniture, and it in turn speaks to us about our world, reflecting not only our own dreams and aspirations but also those of our culture. As our most constant companion, furniture is a source of reflection, meditation, and inspiration."[112]

Simpson's art splendidly echoes this premise, and he pictures himself as a per- son who expresses his response to life through joyful creativity. "I was lucky enough

A

to have a carefree, Tom Sawyer–like child-hood," remarks Simpson. "I had the freedom to explore, investigate, and marvel at nature's wonders."[113]

Simpson's love of life, art, and the materials for making art reverberate in all of his creations. By respecting the time-honored techniques of fine woodworking and joinery, faux finish, and punched-tin work, he celebrates and extends the legacy of American crafts, at the same time gently poking fun at outmoded tenets and blink-ered critics who have forgotten how to laugh.

Much of the content of Simpson's art evolves from childhood memories and reconstructions of personal and historical events. *Race You to the Top* (1995) grew from one such experience: "As I was riding my bicycle home from youth fellowship, the song *Jacob's Ladder* kept circling through my mind with the imagery of heaven and death. The ride was the making of a strange ladder to glory." *G. W. Cabinet* (1994), a wood cabinet with a faux finish, was inspired by the apocryphal tale of George Washington and the cherry tree. *Romeo and Juliet* (1980) is an ode to lovers everywhere; in visual form it seems to say, "When arrows fly, love's on the wing."

Tommy Simpson was born in Dundee, Illinois, in 1933. He lives in Washing-ton, Connecticut.

A *Touching Blue—Touching Brown,* 1997, carved and painted wooden armoire, 80 x 39 x 18", courtesy of the artist.

B *G. W. Cabinet,* 1994, painted wood cabinet, 76 x 32 x 19", courtesy of the artist.

PREVIOUS PAGE: *Race You to the Top,* 1995, mixed woods, leather, metal bell, and marble, 86 x 28 x 12", courtesy of the artist.

B

Romeo and Juliet, 1980,
painted wooden box, wire,
and steel wool, 40 x 32 x 4",
courtesy of the artist.

Players in Pocket-Size Dramas

The protagonists in Reinhard Skoracki's pocket-size dramas appear to be enacting tragicomedies that have played to audiences since man inherited the earth.

Skoracki's sculptural expressions fit somewhere between traditional satire and black humor. At first glance, one might conclude that his art alludes to a world without hope, or one that no longer believes in heroic utopias. Further contemplation, however, could easily provide a contrary insight—that the seemingly black aura that hovers over his work and invariably provokes nervous laughter can also tweak waves of social consciousness. Ironically, his satire succeeds by joining together disparate elements of comedy and tragedy that are enveloped in expressions of pathos.

Searching for a Better World (2001) is an amusing narrative tempered with pain. In this tableau, the subject, a homeless person looking in a refuse bin for whatever subsistence he can find, encounters elegant toys and cultural artifacts that have been discarded by the affluent—a bittersweet reminder of the growing distance between the haves and the have-nots in a seemingly opulent culture.

In *Peas of Mind* (1997), human heads are shown tightly packed in a peapod, a visual pun that points to a tragic irony in urban living—that many people live in close, but alienated proximity. Unlike black humor, which presents a world gone mad and without hope, Skoracki's art is admittedly caustic satire, but closer to Pantagruelism—the Rabelaisian philosophy of dealing with serious matters in a spirit of broad and somewhat cynical good humor.

Skoracki's bronze sculptures are typically small scaled, averaging twelve inches in

REINHARD SKORACKI

PROFILE 43

PREVIOUS PAGE: *Rogues Stealing the Earth,* 2002, bronze, 15³/₄ x 19¹/₂ x 8", courtesy of the artist.

height. The figures are first modeled in clay, then cast in wax from plaster or silicone molds. The wax figures are refined with miniature dental and shop tools, and then sent to the foundry to be cast in bronze. Finally, the bronze castings are cleaned, and a patina that may vary in color from golden brown to earthy green is applied to the surface.

Skoracki's knowledge of human anatomy is grounded in the tradition of high Italian Renaissance—as represented by Michelangelo and Benvenuto Cellini— a style reflected in many of his figurative pieces. However, in some cases, as in *Rogues Stealing the Earth* (2002), he shifts to a simpler, blockier style that nods to the bowler-hatted figures of René Magritte.

Reinhard Skoracki was born in 1942 in Gross-Hesepe, Germany. He lives in Calgary, Alberta.

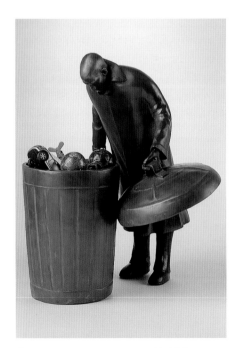

Searching for a Better World, 2001, bronze, 7 x 6¹/₂ x 6", courtesy of the artist.

Peas of Mind, 1997, bronze, 4 x 8 x 1¹/₂", courtesy of the artist.

Why I Fish

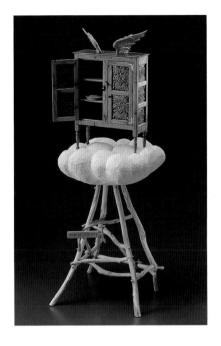

Superior's patently absurd machines and utopian contrivances may not change the way we live, but they do have the capacity to elevate spirits and to change frowns into smiles.

Although originally trained as an illustrator, painter, and printmaker, Superior taught himself the technique of woodcraft with which he fabricates his elaborate utopian contraptions. "At the beginning of my woodworking career, I focused primarily on making full-size furniture, and then about twenty years ago, I began to make sculptural objects on a miniaturized scale."[114]

Superior's bantam-size machines (which display a proficiency of woodworking skills worthy of a master craftsman) actually work. As Superior explains, "My goal is to combine fine craftsmanship with the wonders of engineering, along with the nostalgia of historical reference, and some satire for spice, visual excitement, and sociological relevancy. When people ask why I choose to make impractical contrivances, I say my objects are no more or less absurd than the mechanical devices that surround us in our daily life."[115]

In his Rube Goldberg–like tour de force *When Pigs Have Wings* (1981), Superior gets us to laugh at the ingenuity of his foolish invention and at the satiric broadside it fires at a culture mesmerized by gadgets and silly contrivances.

Pie in the Sky (1996) is an amusing reconstruction of the old saw that declares, "Work and pray, live on hay, you'll get pie in the sky when you die."

In *The Muse Leaves Messages* (1991), he presents a finely crafted reliquary that includes a miniature workbench and tools, along with selected aphorisms relating to the woodworker's art.

Superior's art is in tune with the spirit of early Americana and with the grand tradition of wood. Many of his pieces are examples of how antiquities can be given a new twist by a comic-minded revisionist. Superior's love for vintage, one-of-a

ROY SUPERIOR

PROFILE 44

137

PREVIOUS PAGE: *Pie in the Sky,*
1996, wood, 24 x 12 x 12",
courtesy of the artist.

kind objects is exemplified by his extensive collection of woodworking tools and by his passion for wood sculpture.

In Eric Sloane's *A Reverence for Wood,* the author notes that in 1765 everything a man owned was made more valuable by the fact that he had made it himself, or knew exactly from where it had come. That century of magnificent awareness preceding the Civil War was the age of wood, and wood was not simply the material for building a new nation—it was an inspiration. William Penn described it as "a substance with a soul."[116]

Like the craftsmen of that era, Superior entertains a reverence for wood and the patience to bring out the best from this material. By its very nature, the crafting of highly finished objects is a painstakingly slow process. Superior is quick to note the practitioner needs an occasional restorative break, a phrase that in his lexicon means, "I'm going fishing!" It is not difficult to see why fishing is such an apt metaphor for this truly creative artist.

As Superior speaks of the frustrations of fishing, he draws an apt analogy to life and to art: "One tries, often fails, yet feels no sense of failure in not having caught the fish. The experience of fishing, like the practice of craft, carries moral lessons for those patient enough to learn."[117]

Roy Superior was born in 1934 in New York City. He lives in Williamsburg, Massachusetts.

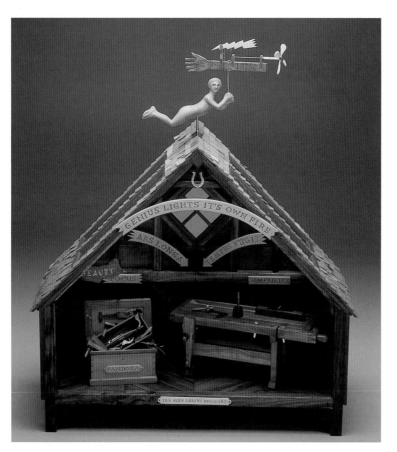

*The Muse Leaves Messages,*1991, wood, 24 x 24 x 13", courtesy of the artist.

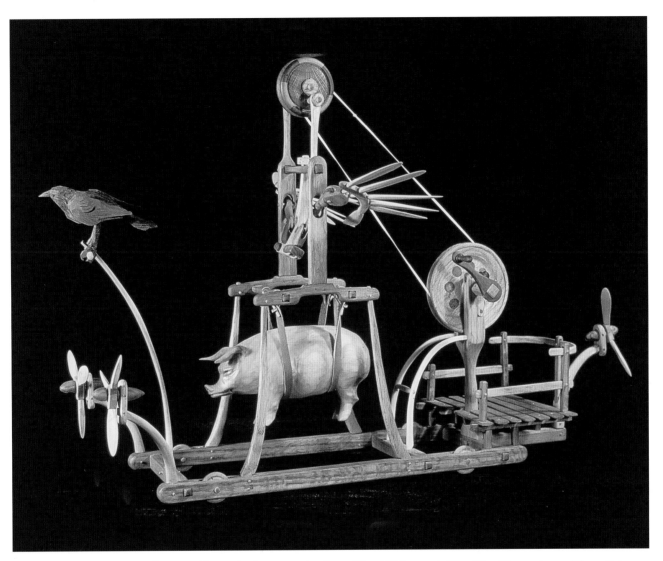

When Pigs Have Wings, or Bringing Home the Bacon as the Crow Flies, 1981, wood, 18 x 20 x 8", courtesy of the artist.

Sculpture à la Mode

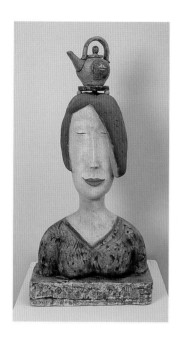

PETER VANDENBERGE

PROFILE 45

One day in the summer of 1962, Peter VandenBerge happened to stop at Bob Arneson's booth at the California State Fair. He watched rapturously as Arneson formed cylindrical-shaped clay vessels on a potter's wheel and then abruptly turned them into forms resembling soda pop cans. It was a whimsical performance, yet it was also an act of rebellion by an artist frustrated by the current mainstream attitude toward ceramic art as craft rather than fine art. Arneson's seditious act of capping a clay pot served notice that henceforth, ceramic art was to be emancipated from its utilitarian function and to be regarded from the perspective of fine art.

Arneson's chutzpah in defying the twin taboos of art—using clay to make fine art, and marrying humor and fine art—were actions of spirited dissent that exhilarated the young VandenBerge, who was inspired to join Arneson at the University of California, Davis, and to become one of Arneson's first graduate students.

Fueled by the rich experiences at Davis, VandenBerge followed the yellow kiln-brick road to a successful career spanning thirty years as a ceramic sculptor and educator. While teaching at Alfred University in 1974, VandenBerge produced an unusual figurative work of clay that procreated his now-famous signature motif: a large-scale ceramic bust crowned with the image of a diminutive animal.

Most of VandenBerge's contemporary ceramic busts are hand-built, using the traditional coil method and embellished with underglazes and bright polychrome finishes. Many of his ceramic sculptures are gigantic, measuring four to seven feet in height. Their thin, elongated configuration is reminiscent of the centuries-old, monolithic sculptures on Easter Island, the stylized and elongated figures in paintings by Amedeo Modigliani (1884–1920), and the skeletal and stretched figures by Alberto Giacometti (1901–66).

VandenBerge recounts the boldness of his youth when he once knocked on Giacometti's door in southern Paris and asked the renowned master, "Could I see you sculpt?" And, to his surprise, Giacometti agreed—a meeting that left an indelible impression on the neophyte sculptor.

VandenBerge's zany action of crowning a sculpted, Giacometti-like head with an irrelevant subject like a farm animal instantly transforms the figure into a comically surreal and potentially metaphoric image. He credits the inspiration for the á la mode motif as having evolved from recollections of his life in Indonesia, where he observed people customarily carrying things on their heads. VandenBerge believes that the value we place on our accumulated possessions—whether

they be appliances, toys, objects, ideas, experiences, deeds, dreads, or emotions—is indeed a contributing factor to the growth or inhibition of character development and individuality.

VandenBerge's *Animalman II* (1989/1992)—a sculpture of a head with a small cow placed on top—comes from his boyhood recollections of bucolic country life in Holland. "*Animalman* is about the closeness between man and his animals," he explains. "The animal is placed on top because it is regarded with great respect and priority."[118]

Automan (1990) poses a question that refers to a contemporary American obsession—the automobile. "Indirectly," says VandenBerge, "it asks, Does the kind of car a man drives identify his worth?"[119]

Aside from metaphoric speculation that VandenBerge's art provokes, there is also an undeniable humorous element that is intrinsic and that springs from its ironic posture: the pairing of highly disparate elements—a juxtaposition that would make even the hard-core dadaist smile.

Peter VandenBerge was born in 1935 in The Hague, Netherlands. He lives in Sacramento, California.

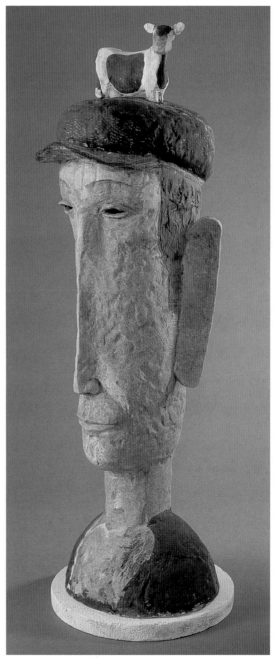

OPPOSITE: *Hostess,* 1998, fired clay with polychrome finish, 40 x 28 x 18", courtesy of the artist.

Animalman II, 1989/1992, fired clay with polychrome finish, 50 x 13", courtesy of the artist.

Figuratively Speaking

PATTI WARASHINA

PROFILE 46

Artists sympathetic to the nature of clay are mindful that this earthy material is in itself a metaphor of genesis. Clay is described in the Scriptures as the material from which the body of the first human was formed. "I also am formed out of the clay," says Job (33:6). Accordingly, Patti Warashina uses clay as a canvas to record emotions and thoughts that parallel her life experiences. From the nascent stages of her development as an artist, she has taken an independent direction, telling of evolution and encounters of patriarchy in the art world, gender inequality, women's roles in American culture, male-female relationships, and the quest for personal identity and happiness.

Warashina's ceramic tableaus of the late 1970s are portraits of women in compliant roles of domesticity. The imagery from this period is cloaked in wry, self-deprecating humor and appears both cathartic and celebratory. From one perspective it speaks of adversity and subjugation and, from another, it signals the advent of transformation, independence, and self-assuredness. A psychologist would distinguish Warashina's images as symbols of regeneration, for it is only with a strong sense of self-confidence that people can poke fun at themselves.

In the 1990s, Warashina began to make larger-than-life-size figures, some fourteen feet high, a radical departure from her preceding bantam-sized figures. Again, with characteristic wit and skill, her sculptures address issues concerning conventional expectations of women and clichéd gender roles—concerns she carries forth in works such as *Needler* (Mile Post Queen series, 2002).

"I see my recent figures," says Warashina, "as a personal guidepost, hence the title of the series Mile Post Queens, referring to markers of a psychological time line that references various Asian, American, and Mediterranean counterparts. The hybridization of these figurative cultural archetypes brings the counterparts together to speak about personal myths of life and transition."[120]

Warashina's modus clearly reflects relief theory, which suggests that humor acts as a source of catharsis and spiritual rejuvenation. "Since I embarked on my journey as an artist, the image of the human body has been an absorbing visual

fascination," says Warashina. "It gives me a reference point to my own existence, the civilization in which I live, as well as my relationship to a historical past."[121]

Patti Warashina was born in 1940 in Spokane, Washington. She taught at the University of Washington, Seattle, for twenty-five years before retiring to devote herself full time to making art in Seattle.

OPPOSITE: *A Cry for Help*, 1982, clay and mixed media, 23 x 24 x 20", courtesy of the artist.

Portrait #5 (Rome series), 2000, clay, glaze, and underglaze, 24 x 23 x 18", courtesy of the artist.

Needler (Mile Post Queen series), 2002, ceramic on metal base, 34 x 9 x 11" plus 25" steel base, courtesy of the artist.

Real/Surreal: A Comic Felicity

JOHN WILDE

PROFILE 47

John Wilde's paintings are not large, yet they present heroic spectacles of enchantment. They are at once amusing, cloaked in mystery, and a salute to the surrealist's notion that absurdity is not just absurdity, but a "super sensing" of reality.

What distinguishes Wilde (pronounced "will-dee") from other realist painters is not his technical virtuosity—which is clearly brilliant, and reminiscent of early Flemish and Italian Renaissance masters—but rather, the pictorial content of his paintings, which is dreamlike and surreal. In his book *Creativity: The Magic Synthesis*, psychologist Silvano Arieti explains that the transfiguration of the dream— the delusion, the hallucination—is not a deformation, but an enrichment of life.[122]

Wilde's mythomania flourishes in a garden of hyperbole and irony, combining incongruity, reversal, transposition, and grotesquerie. It blossoms in the fertile landscape of erotic whimsy, tragic mirth, and comic morbidity.

Like the disturbing and irrational art of Dalí, René Magritte, and Max Ernst, Wilde's images are unsettling, yet they prompt viewers to expand their modes of perception.

Wilde's surrealism nods not only to antecedent masters of twentieth-century surrealism, but to the Italian Baroque artists who preceded the surrealists: Il Guercino (Giovanni Francesco Barbieri, 1591–1666) and his absurd monsters of the mid-1600s, as well as father and son artists Giovanni Battista Tiepolo (1696–1770) and Giovanni Domenico Tiepolo (1727–1804), creators of the grotesquely comic Pulcinella and Punchinello paintings.

Viewing Wilde's art makes one realize that although surreal art is inconsistent with nature and common sense, it is in perfect accord with the fundamental tenet of creativity: that suspension of judgment and reason is obligatory so innovation may be accessed from the unconscious.

"What happens in a work of art is a disruption of the logic of it all," says Wilde. "Sometimes strange relationships between figures occur as soon as I start working on something. I respond to this with, 'That's okay; that's all right, that interests me,' and then I pursue it."[123]

View Near Stebbinsville Road with a Giant Kohlrabi (1983) presents a comically surreal recontextualization created by reversing the normal proportion between a man and a garden vegetable. Wilde's imagery conforms to incongruity theory, which posits the notion that thinking in opposites is fun, but it also jolts the viewer with its latent declaration that ambiguity is no joke, but rather is an integral

component of reality. Wilde's glorification of the mysterious and the enigmatic comes with an endorsement for humor and inducement for laughter.[124]

More Festivities at the Palazzo San Severini (1951–52) is a meticulously rendered painting of nudes and partially clad women reminiscent of Italian Renaissance painting. Here, the surprising composition and iconography are amusing because of ludicrous reversals and contradictions.

What joys and expectations does John Wilde, now an "elder statesman" of American realist painting, have of the future? "None!" he exclaims. "None, excepting the joy of the moment, the awe of the vision, the possibility of the morrow and of seeing a leaf not seen before, of finding a new nuance of pigment, or tasting afresh that tasted ten thousand times before."[125]

John Wilde was born in 1919 in Milwaukee, Wisconsin. He lives in Cookville, Wisconsin.

View Near Stebbinsville Road with a Giant Kohlrabi, 1983, oil on panel, 10 x 12", Schmidt-Bingham Gallery, New York.

More Festivities at the Palazzo San Severini, 1951–52, oil on panel, 20 x 24¼", Schmidt-Bingham Gallery, New York.

Nine Crazy, Smiling, American Girls, a Dog and a Cat at My Place, 1961, oil on panel, 12 x 18", Schmidt-Bingham Gallery, New York.

Nothing and Everything's Comparable

Artists and poets place substantial value on the search for necessary correspondences, that is, literary and visual analogies, because they provide links between objects of perception and objects of expression. William T. Wiley's art pivots on his talent for creating eccentric analogies by juxtaposing polar opposite elements that are forced to operate in the same pictorial and psychological space.

Wiley's art sprouts from a life examined, and it is inspired by Buddhist beliefs that encourage one to view life as a series of changes and self-discoveries that are reflected in the interplay of ambiguous and seemingly contradictory images.

"He is a gentle fatalist, a sort of Zen existentialist," writes Brenda Richardson. "He accepts everything—ideas, events, people—as having equal value and equal potential. For Wiley, acceptance of the human condition is not merely an abstract concept, it is a way of life and a modus operandi for studio practice."[126]

The need to be an individual in an increasingly incorporated society began for Wiley during his student years at the San Francisco Art Institute in the 1960s. With encouragement from his instructor Frank Lobdell, he began to develop an expressive style based on ideas associated with personal experience, culture, history, and myth. His individuality germinated at the University of California, Davis, in 1962, where he taught alongside Robert Arneson, Wayne Thiebaud, Roy De Forest, and Manuel Neri.

Wily's curiosity and wit have prompted him to explore perceptions from his inner and outer worlds for the greater part of four decades. To many, his name is synonymous with the San Francisco Bay Area's funk movement. However, as critic Beth Coffelt notes, if anyone gets anywhere close to defining him, "he transubstantiates."[127]

Mr. Unatural is Wiley's alter ego—an imaginary character conceived in his own likeness whose behavior fluctuates between foolish and foolishly wise and who is readily identified by his eccentric attire: a black kimono, dunce hat, false

WILLIAM T. WILEY

PROFILE 48

nose, black mustache, Japanese wooden clogs, and magic wand, with a child's slate hanging from his neck. Mr. Unatural frequently appears in Wiley's performance pieces and graphic art.

In the 1990s, Wiley evolved a narrative style in which he re-visions masterworks of art history. In *Manet Can't Paint the Ocean Like Eye Can* (1995), for example, Wiley paraphrases the image of Edouard Manet's *The Battle of the Kearsage and the Alabama* (1864), but he adds a large pink fish and some graffiti scribbles that turn his image into a contemporary satire that pleads for the endangered salmon, an ocean species on the verge of extinction. The analogy between the two ships battling for survival and the salmon's equivalent plight is uniquely poignant.

Learning and Education with Professor Hugh Bruss, 1997, charcoal and acrylic on canvas, 60 x 40", courtesy of Wanda Hansen.

Manet Can't Paint the Ocean Like Eye Can, 1995, acrylic, charcoal, and ink on canvas, 69¹/2 x 82", courtesy of Wanda Hansen.

In *Modern Ark, After Bruegel* (1995), Wiley takes Bruegel's *Battle Between Carnival and Lent* (1559) and turns it into a satire that skewers the inconsistent standards of political ideology. Wiley's graffiti refers to verbal disputes between Republicans and Democrats and to the battles between the political right and left in the U.S. Congress.

Wiley's irony and cynical wit may draw laughter, but through the mist of its comic iconography, a veiled message appears: life is full of anomalies, and they are all gifts, if you know how to accept them.

William T. Wiley was born in 1937 in Bedford, Indiana. He lives in Woodacre, California.

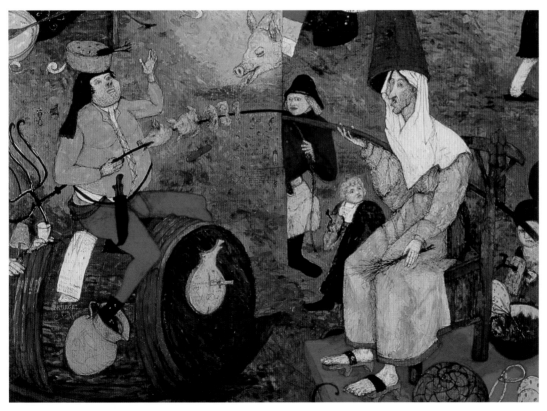

Modern Ark, After Bruegel, 1995, acrylic on canvas, 70 x 93", courtesy of Wanda Hansen.

Madcap Mélange

Trevor Winkfield's studio is a funhouse of merriment and mischief making, the kind of place where formal design and comic surrealism come together and evolve spirited narratives from a hodge-podge of visual fragments.

Winkfield's paintings are brightly colored, hard-edged compositions comprised of diverse and disjointed elements—hands, faces, wearing apparel, animals, vegetables, clocks, wheels, mechanical devices, heraldic patterns, et cetera, all of which are ingeniously arranged to form unities that are amusing, befuddling, and thought provoking.

Winkfield's heraldic imagery recalls historical references, such as medieval and Victorian art and pageantry, ancient relics, codices, and ceremonial rites. There is also an aspect of dadaism and pop art, tinged with Winkfield's unconventional sense of humor, which recalls the writings of Lewis Carroll and Jonathan Swift.

Winkfield, British by birth, moved to New York in his twenties in 1969, where he continues to work. His art seems to earmark a sensibility from both continents—the disposition of Edwardian humor and the flavor of the crisply defined edges and flat color of American hard-edge painting.

From the standpoint of composition, Winkfield's designs, which at first glance may appear chaotic, are in fact well grounded on a matrix not unlike the geometric foundations of Piet Mondrian's neoplastic compositions. Similarly, Winkfield's jumble of images from culture, history, and myth are invariably fixed on a grid that breaks the flat picture plane into receptive rectangular shapes. Making pictorial sense with visual non sequiturs appears to be Winkfield's forte, a specialty that is evident in his skillful blend of ambiguity and refinement.

There is no such thing as "nonsense" apart from a judgmental intellect that calls it that.

— GARY ZUKAV,
*THE DANCING
WU LI MASTERS*

TREVOR WINKFIELD

PROFILE 49

150

"The thrill of Winkfield's juxtapositions has something to do with the puzzle's not quite falling into place," explains critic Jed Perl. "The confounding occurrences in his painting are something more than accidents, they suggest a general principle of poetic unpredictability which we may be more familiar with in the work of writers than of painters."[128]

In Winkfield's Voyage series, the enigmatic composition appears to refer to the artist's love for travel. Although mysterious, one might sense the painting's metaphoric implication is of virtual travel via intellectual and aesthetic encounters, for it is through the mind that new territories are charted, consciousness enlarged, and human potential expanded.

Are Winkfield's paintings metaphorically potent, or are they merely self-indulgent exercises in visual nonsense? To properly address the question, one must keep in mind that a contemporary definition of "nonsense"—particularly for the artist and poet—is not something that makes no sense, but rather something that is ambiguous, yet is also a procreative construct that has the potential of becoming meaningful, sometimes with profound sense.

Trevor Winkfield was born in 1944 in Leeds, England. He lives in New York City.

OPPOSITE: *The Student,* 1999, acrylic on linen, 46 x 55^{1}/$_{2}$", Tibor de Nagy Gallery, New York.

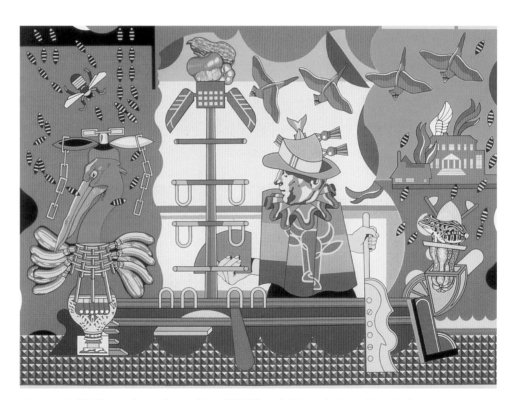

Voyage V, 1998, acrylic on linen, 52 x 72", Tibor de Nagy Gallery, New York.

The Shadow of Your Simile

A lot of Shakespeare sounds like nonsense, and is meant to; though—out of deference to the logicians in his audience— he usually has a kernel of meaning in it.

—ANTHONY BURGESS,
WRITER

Karl Wirsum is proudly parochial. Born, raised, and educated in Chicago, he has spent all but a brief three-year period (while teaching at Sacramento State University in California, from 1971 to 1973) living in America's Second City.

Collectors and devotees have dubbed him the "Clown Prince of Art," an appellation that, when considered from the perspective of his outrageous visual expression, is well deserved. Wirsum's finely crafted art is dedicated to figurative imagery and is rendered in a highly distorted, cartoonlike style, sometimes in geometric, robotlike form, but always in a singularly incongruous syntax. His mediums include drawing, printmaking, painting, and sculpture.

Wirsum is a graduate of the School of the Art Institute of Chicago, and he is an original member of The Hairy Who. Wirsum and his colleagues rejected abstractionism in favor of their own brand of figuration—an impudent and high-spirited imagery drawn from popular culture, advertising, the comics, outsider and folk art, and the art of psychotics. Permeated with elements of surrealism and art brut, their art was anything but traditional.

Although the days of The Hairy Who are long past and its members have gone their separate ways, Wirsum's art continues to prosper and evolve through comic figuration, but in new contexts and stylistic modes. He maintains a reference to the human body as a source of meditation and as a base for comic abstraction. His art is also inspired by contemporary American obsessions—electronic games and gadgets, robotics, science fiction, pop music, and sporting events. Satire, too, lurks below the surface of Wirsum's puns and comic wordplay.

Practicing Duck Calls at the Potato Chip Pavilion (1992), for example, is a poke at America's passion for interactive arcade games. Wirsum's wacky titles add additional humor, as well as paradox, to his cartoon imagery.

KARL WIRSUM

PROFILE 50

The astute spectator may reasonably suspect that many of Wirsum's paintings are more than just whimsical representations, that they evolve from deeply felt ethics and social concerns. "If we permit Wirsum's work to do more than charm us, we are forced to confront our own temporality, not to mention certain of our collective expectations about what constitutes important and serious art," notes critic Dan Cameron. "His art is inextricably bonded to the human spirit through its bathos. Whatever else it is, Wirsum's art is an antidote to a culture of material distractions."[129]

Karl Wirsum was born in Chicago in 1939. He lives in Chicago.

PREVIOUS PAGE: *F Sharp Knee Jerk Twist,* 1996, acrylic on wood, 59 x 36", Jean Albano Gallery, Chicago.

O Bald! Music at Dawn, 1995, acrylic on wood, 39 x 43", Jean Albano Gallery, Chicago.

Mr. Answer Pants, 1991, acrylic on wood, 49¹/2 x 36 x 9", Jean Albano Gallery, Chicago.

Practicing Duck Calls at the Potato Chip Pavilion, 1992, acrylic on canvas, 44^{1}/$_{2}$ x 64^{1}/$_{2}$", Jean Albano Gallery, Chicago.

Humor is the final sign and seal of seriousness, for it is a proof that reality is held in honor and in love.

—Mark Van Doren, Writer

Norman Catherine. *Endangered Species,* 2000, oil on mixed media, 70 x 49 x 4", collection of the Standard Bank, Johannesburg South Africa, courtesy of the artist.

bibliography

1. Bakhtin, Mikhail. *Rabelais and His World.* Bloomington: Indiana University Press, 1984.

2. Cousins, Norman. *Anatomy of an Illness as Perceived by the Patient*, New York: Norton, 1979.

3. Davis, Murray S. *What's So Funny*, Chicago: University of Chicago Press, 1973.

4. Culler, George D. "Dada and Surrealism." *Art in America*, volume 51 (2), April 1963.

5. Rowell, Margit. *Jean Dubuffet: An Art in the Margins of Culture.* New York: Solomon R. Guggenheim Foundation, 1973.

6. See note 5 above.

7. Rosenberg, Harold. "The Art World and Marilyn Mondrian," *The New Yorker*, November 8, 1969.

8. Oldenburg, Claes. "Lichtenstein, Oldenburg, Warhol: A Discussion." By Bruce Glaser. *Art Forum*, volume IV (6), 1966.

9. Barthes, Roland. *That Old Thing, Art*, quoted in *Pop Art: The Critical Dialogue*, by Carol Anne Mahsun, Ann Arbor, Mich.: UMI Research Press, 1989.

10. Canaday, John. *The New York Times Magazine*, p. 30, May 31, 1964.

11. Landauer, Susan. In *The Lighter Side of Bay Area Figuration*, Kansas City, Mo.: Kemper Museum of Contemporary Art, 2000. An exhibition catalog.

12. *Robert Beauchamp: An American Expressionist.* Edited by Ronald Kuchta. Syracuse, New York: Everson Museum of Art, 1984. An exhibition catalog.

13. Askin, Walter. Memos to author, 2000.

14. One Flew Over the Cuckoo's Nest. 133 min. Fantasy Films/United Artists, 1975.

15. See note 13 above.

16. See note 13 above.

17. Kuspit, Donald. *Sight out of Mind*, Ann Arbor, Mich.: UMI Research Press, 1985.

18. Bailey, Clayton. Memos to author, 2000.

19. See note 18 above.

20. See note 18 above.

21. Barrish, Jerry Ross. Memos to author, 2000.

22. See note 21 above.

23. See note 22 above.

24. Seitz, William C. *The Art of Assemblage*, New York: The Museum of Modern Art, 1961.

25. See note 21 above.

26. See note 21 above.

27. See note 21 above.

28. Blumenstein, Mark. Memos to author, 2000.

29. See note 28 above.

30. Bryan, Mark. Memos to author, 2000.

31. See note 30 above.

32. Jung, C. J. *Jung on Active Imagination*, edited by Joan Chodorow, Princeton, New Jersey: Princeton University Press, 1997.

33. See note 30 above.

34. Metcalf, C. W. and Felible, Roma. *Lighten Up: Survival Skills for People Under Pressure*, Reading, Mass.: Addison-Wesley, 1992.

35. See note 30 above.

36. Bulwinkle, Mark. Memos to author, 2001.

37. See note 36 above.

38. See note 36 above.

39. See note 36 above.

40. Buonagurio, Toby. Memos to author, 2000.

41. See note 40 above.

42. See note 40 above.

43. Cicansky, Victor. Memos to author, 2001.

44. See note 43 above.

45. Coe, Anne. Memos to author, 2002.

46. See note 45 above.

47. See note 45 above.

48. Angelou, Maya. "In Conversation with bell hooks," *Shambhala Sun*, January 1998.

49. Rosenberg, Harold. *On Violence in Art and Other Matters*, Chicago: University of Chicago Press, 1985.

50. Cox, Richard. In *Warrington Colescott: Forty Years of Printmaking*, Madison, Wisc.: Elvehjem Museum of Art, 1988. An exhibition catalog.

51. See note 50 above.

52. See note 50 above.

53. Jones, Ronald. *The Funny Biology of Evil*, Boston: School of the Museum of Fine Arts, 1995.

54. Press release in conjunction with Carrol Dunham exhibition, New York: Metro Pictures, 2000.

55. Nordness, Lee. *Jack Earl: The Genesis and Triumphant Survival of an Underground Ohio Artist*, Racine, Wisc./Chicago: Perimeter Press, Limited, 1985.

56. See note 55 above.

57. Farley, Janice. Memos to author, 2002.

58. International Encyclopedia of Quotations, Chicago: J. D. Ferguson, 1978.

59. Ferrari, Gerard. Memos to author, 2000.

60. Freud, Sigmund. *Jokes and Their Relation to the Unconscious*, translated by James Strachey, New York: Norton, 1960.

61. van Boxsel, Matthijs. *The Encyclopedia of Stupidity*, London: Reaktion Books, 2003.

62. Gilbert, John Martin. Memos to author, 2002.

63. See note 62 above.

64. See note 62 above.

65. Gilhooly, David. Memos to author, 1999.

66. Hurni, C.W. Memos to author, 2001.

67. See note 66 above.

68. See note 66 above.

69. Meisel, Louis K. *Photorealism*, New York: Harry N. Abrams, 1980.

70. Pierre, Jose. *Guy Johnson*, Paris: Filipacchi, 1988.

71. Newman, Richard. Memos to author, 2000.

72. See note 71 above.

73. Russick, David. In *Gladys Nilsson, Works from 1998–99*, Chicago: Jean Albano Gallery, 2000. An exhibition catalog.

74. See note 73 above.

75. Nutt, Craig. Memos to author, 2001.

76. See note 75 above.

77. Onofrio, Judy. Memos to author, 2002.

78. Kuspit, Donald. In *Charles Parness's Comic Self-Portraits*, Manitowoc, Wisc.: Rahr-West Art Museum, 1997. An exhibition catalog.

79. Parness, Charles. Memos to author, 2003.

80. See note 79 above.

81. See note 79 above.

82. Paschke, Ed. Memos to author, 2003.

83. Minsky, Marvin. *Society of Mind*, New York: Simon & Schuster, 1986.

84. See note 32 above.

85. Picco, Jim. Memos to author, 2000.

86. Tigges, Wim. *Explorations in the Field of Nonsense*, Amsterdam: Rodopi, 1987.

87. Purdy, Gerald. Memos to author, 2000.

88. Adelson, Warren. In *The Sculpture of Peter Reginato*, New York: Adelson Galleries, 2000. An exhibition catalog.

89. Waddington, C. H. *Behind Appearance: The Study of the Revelations between Painting and the Natural Sciences*, Cambridge, Mass.: MIT Press, 1970.

90. Kandinsky, Wassily. *Concerning the Spiritual in Art*, New York: Dover Publications, 1977.

91. Reginato, Peter. Memos to author, 2001.

92. See note 91 above.

93. Reginato, Peter. In conversation with Warren Adelson and William Beadleston. *Peter Reginato*, New York: Adelson Galleries, 1994. An exhibition catalog.

94. Osborne, Harold, ed. *The Oxford Companion to Twentieth-Century Art*, London: Oxford University Press, 1981.

95. Vasari, Giorgio. *Lives of the Artists*. New York: Harry N. Abrams, 1979.

96. Rogula, Ann. Memos to author, 2000.

97. See note 96 above.

98. See note 96 above.

99. Rosenbaum, Allan. Memos to author, 2001.

100. See note 99 above.

101. Miller, Bonnie J. *Why Not? The Art of Ginny Ruffner*, Seattle: University of Washington Press, 1995.

102. Linden, Jennifer Wolcott. "Trash into Treasure," *The Christian Science Monitor*, July 9, 1991.

103. Sewell, Leo. Memos to author, 2000.

104. See note 103 above.

105. Shaw, Richard. Memos to author, 2003.

106. Sheldon, Mick. Memos to author, 2002.

107. See note 106 above.

108. See note 106 above.

109. Shimomura, Roger. Memos to author, 2000.

110. Simpson, Tommy. Memos to author, 2000.

111. See note 110 above.

112. Joseph, Peter. "Angel Chairs: The Art of Wendell Castle." In *Our Chosen Canvas*, New York: Peter Joseph Gallery, 1991. An exhibition catalog.

113. See note 110 above.

114. Superior, Roy. Memos to author, 2002.

115. See note 114 above.

116. Sloane, Eric. *A Reverence for Wood*, New York: Ballantine Books, 1989.

117. Metcalf, Bruce. "The Work of Roy Superior," *American Craft*, Fall, 1995.

118. VandenBerge, Peter. Memos to author, 2000.

119. See note 118 above.

120. Warashina, Patti. Memos to author, 2002.

121. See note 120 above.

122. Arieti, Silvano. *Creativity: The Magic Synthesis*, New York: Basic Books, 1976.

123. Wolff, Theodore F., and Panczenko, Russell. *Wildeworld: The Art of John Wilde*, New York: Hudson Hills Press, 1999.

124. See note 123 above.

125. *Looking Forward and Back: The Art of John Wilde*, New York: Schmidt-Bingham Gallery, 1996. An exhibition catalog.

126. Richardson, Brenda. In *William T. Wiley*, Tallahassee, Fla.: University Fine Arts Galleries, 1981. An exhibition catalog.

127. Coffelt, Beth. In *William T. Wiley*, Tallahassee, Fla.: University Fine Arts Galleries, 1981. An exhibition catalog.

128. Ashbery, John, and Perl, Jed. *Trevor Winkfield's Pageant*, West Stockbridge, Mass.: Hard Press, 1997.

129. Cameron, Dan. In *Karl Wirsum: A Retrospective*, New York: Phyllis Kind Gallery, 1986. An exhibition catalog.